山口晃作品集

発行日　2004年10月19日　初版
　　　　2004年12月24日　第3刷

画————————山口 晃
翻訳————————山崎 淳・Susan Schmidt・Stephen Snyder
アートディレクション————鈴木 堯［タウハウス］
デザイン————————佐々木由美・小林 煌［タウハウス］
編集協力————————藤城里香［ミヅマアートギャラリー］・広瀬麻美
　　　　　　　　　株式会社 ミヅマアートギャラリー
発行所————————財団法人 東京大学出版会
　　　　　　　　　代表者 五味文彦
　　　　　　　　　113-8654 東京都文京区本郷7-3-1　東大構内
　　　　　　　　　電話：03-3811-8814　Fax：03-3812-6958
　　　　　　　　　振替：00160-6-59964
印刷所————————杜陵印刷株式会社
製本所————————矢嶋製本株式会社

©2004 Akira Yamaguchi／無断転載禁止
ISBN 4-13-083100-3

The Art of Akira Yamaguchi

First Published in Japan, October 19, 2004
Third Printing, 2004

Paintings————————Akira Yamaguchi
Translation————————Jun Yamazaki, Susan Schmidt, Stephen Snyder
Art Direction————————Takashi Suzuki [Tauhaus]
Design————————Yumi Sasaki, Kou Kobayashi [Tauhaus]
Editorial Cooperation————Rika Fujiki [Mizuma Art Gallery], Mami Hirose
　　　　　　　　　　Mizuma Art Gallery Co., Ltd.
Publisher————————University of Tokyo Press
　　　　　　　　　　Representative: Fumihiko Gomi
　　　　　　　　　　7-3-1 Hongo, Bunkyo-ku, Tokyo, 113-8654, Japan
　　　　　　　　　　Tel: +81(0)3-3811-8814 Fax: +81(0)3-3812-6958
　　　　　　　　　　Postal transfer: 00160-6-59964
Printing————————Toryo Printing Co., Ltd.
Binding————————Yajima Book Binding Co., Ltd.

作家略歴

山口 晃 （やまぐち あきら）

1969 東京生まれ
1994 東京藝術大学美術学部絵画科油画専攻卒業
1996 東京藝術大学大学院美術研究科絵画専攻（油画）修士課程修了
[主な個展]
1998 「イスのある茶室」 ミヅマアートギャラリー／東京
1999 「借景」 ミヅマアートギャラリー／東京
2000 ミヅマアートギャラリー／東京
2001 「畫を描く歓び」 ミヅマアートギャラリー／東京
2002 「日清日露戦役擬畫」 ナディッフ／東京
2003 「『山口晃展』展」 ミヅマアートギャラリー／東京
2004 「山口晃 挿画［菊燈台］」 ナディッフ／東京
 ミヅマアートギャラリー／東京
[主なグループ展]
1997 「WALKING MUSEUM」 高島屋タイムズスクエア／東京
 「こたつ派」 ミヅマアートギャラリー／東京
1998 井上画廊／東京
1999 井上画廊／東京
 「A Window, Inside and Outside」 光州市立美術館／光州（韓国）
2000 「現代美術百貨展」 山梨県立美術館／山梨
 「Five continents and one city」 メキシコ市立美術館／メキシコシティ（メキシコ）
2001 「S(h)itting in the mirror:オレにはオレがこう見える」 ミヅマアートギャラリー／東京
 「第4回岡本太郎記念現代芸術大賞展」 川崎市岡本太郎美術館／神奈川
2002 「新版 日本の美術」 山梨県立美術館／山梨
 「Japan in Blekinge」 Olofstrom Art Exhibition Hall／オロフストルム（スウェーデン）
 「掌8」 レントゲンヴェルケ／東京
2003 「わたしのお宝 交換プロジェクト」 すみだリバーサイドホール・ギャラリー／東京
2004 「MOTアニュアル2004：私はどこから来たのか／そしてどこへ行くのか」 東京都現代美術館／東京
 「Living Together is Easy」 水戸芸術館現代美術センター／茨城
 「MEDIARENA:Contemporary Art from Japan」Govett-Brewster Art Gallery／ニュープリマウス
 （ニュージーランド）
 「開館20周年記念展 コピーの時代」 滋賀県立近代美術館／滋賀
 「OFFICINA ASIA」 Palazzo del Ridotto／チェゼーナ（イタリア）
 「Living Together is Easy」 ヴィクトリア州立美術館／メルボルン（オーストラリア）
[受賞歴]
2001 第4回岡本太郎記念現代芸術大賞優秀賞

Profile of the Artist

Akira YAMAGUCHI

1969 Born in Tokyo, Japan
Education:
1994 Graduated from oil painting course, Tokyo National University of Fine Arts and Music
1996 Completed the course of MA, Tokyo National University of Fine Arts and Music
Selected Solo Exhibitions:
1998 "The Tea-ceremony Room with Chair," Mizuma Art Gallery, Tokyo
1999 "Shakkei (Backdrop)," Mizuma Art Gallery, Tokyo
2000 Mizuma Art Gallery, Tokyo
2001 "The joy of painting," Mizuma Art Gallery, Tokyo
2002 "Records of Japanese-Sino War & Japanese-Russo War," NADiff, Tokyo
2003 " 'Akira Yamaguchi Exhibition' Exhibition," Mizuma Art Gallery, Tokyo
2004 "an illustration, 'A Chrysanthemum lighthouse'," NADiff, Tokyo
 Mizuma Art Gallery, Tokyo
Selected Group Exhibitions:
1997 "WALKING MUSEUM," Shinjuku Takashimaya TIMES SQUARE, Tokyo
 "KOTATSU-SCHOOL," Mizuma Art Gallery, Tokyo
1998 Inoue Gallery, Tokyo
1999 Inoue Gallery, Tokyo
 "A Window (Inside and Outside)," Kwangju City Art Museum, Korea
2000 "Department Store of Contemporary Art," Yamanashi Prefectural Museum of Art,
 Yamanashi
 "Five Continents And One City," Museum of Mexico City, Mexico
2001 "S(h)itting in the mirror, To me, I look like this." Mizuma Art Gallery, Tokyo
 "The 4th Exhibition of the Taro Okamoto Memorial Award for Contemporary Art," Taro
 Okamoto Museum of Art, Kawasaki, Kanagawa
2002 "New Edition! Japanese Art—Other Inheritors of Japanese Tradition," Yamanashi
 Prefectual Museum of Art, Yamanashi
 "Japan in Blekinge," Olofstrom Art Exhibition Hall, Olofstrom, Sweden
 "TANAGOKORO 8," röntgenwerke, Tokyo
2003 "TREASURE for TREASURE: A Treasure Exchange Project with six Artists," Sumida Riverside
 Hall Gallery, Tokyo
2004 "MOT Annual 2004: Where do I come from? Where I am going ?," Museum of
 Contemporary Art, Tokyo
 "Living Together is Easy," Contemporary Art Center, Art Tower Mito, Ibaraki
 "Mediarena: contemporary art from Japan," Govett-Brewster Art Gallery, New Plymouth,
 New Zealand
 "20th Anniversary Exhibition: The Copy Age—From Duchamp through Warhol to
 Morimura," The Museum of Modern Art, Shiga
 "OFFICINA ASIA," Palazzo del Ridotto, Cesena, Italy
 "Living Together is Easy," The National Gallery of Victoria, Melbourne, Australia
Award:
2001 The 4th Taro Okamoto Memorial Award for Contemporary Art

作品一覧

頁	作品名	制作年	素材	寸法	撮影者	所蔵者
1	武具武人総覧圖（部分）	——	——	——	——	
2-3	山乃愚痴明抄	1995	カンヴァスに油彩	91×436.2cm	宮島 径	
4-5	山愚痴諦抄―尻馬八艘飛乃段	1998	カンヴァスに油彩	117.2×549cm	長塚秀人	Soraya & Alfred Jollon
6	山乃愚痴明抄（部分）	——	——	——	——	
7	山愚痴諦抄―尻馬八艘飛乃段（部分）	——	——	——	——	
8-9	當苦おばか合戦　序の巻	1999	カンヴァスに鉛筆、油彩	81×390cm	宮島 径	西脇順也
10-11	當苦おばか合戦	1999	カンヴァスに油彩	97×324cm	宮島 径	高橋龍太郎
12	當苦おばか合戦（部分）	——	——	——	——	
13	今様遊楽圖（部分）	——	——	——	——	
14-15	今様遊楽圖	2000	カンヴァスに油彩	71×342cm	宮島 径	高橋龍太郎
16-17	何かを造ル圖	2001	カンヴァスに油彩	112×372cm	木奥惠三	高橋龍太郎
18	何かを造ル圖（部分）	——	——	——	——	
19	武具武人総覧圖	1996	紙に鉛筆、水彩	170×92cm	宮島 径	宮 誠
20-21	當苦おばか合戦―おばか軍本陣圖	2001	カンヴァスに油彩、水彩	185×76cm	長塚秀人	高橋龍太郎
22	當苦おばか合戦―おばか軍本陣圖（部分）	——	——	——	——	
23	階段遊楽圖（部分）	——	——	——	——	
24-25	階段遊楽圖	2002	カンヴァスに油彩	91×290cm	木奥惠三	静岡県立静岡がんセンター
26-27	五武人圖	2003	紙に墨	各170×60cm	佐藤新一	作家蔵
					提供：東京都現代美術館	
28-29	「日清日露戦役擬畫」より					
28	ミシチェンコ少将	2002	紙に水彩	15×10cm		作家蔵
	儒者	2002	紙にペン、水彩	12×9.7cm		作家蔵
	二〇三高地	2002	紙に鉛筆、水彩	15.3×21cm		作家蔵
	日本巡洋艦 吉野	2002	紙にペン、水彩	12.6×29.5cm		作家蔵
29	旗艦 三笠	2002	紙に鉛筆、水彩	28.5×14.9cm		作家蔵
	二十八サンチ砲	2002	紙にペン、水彩	20.5×18.5cm		作家蔵
	フランス重騎兵	2002	紙に鉛筆、水彩	10×14.8cm		作家蔵
30-31	NHKデジタル放送開始告知番組の為の原画より					
30	「祝 放送開始」	2003	紙にペン、水彩	22.8×35.7cm	木奥惠三	作家蔵
31	「地上デジタル放送成る」	2003	紙にペン、水彩	23.4×39.6cm	木奥惠三	作家蔵
32-33	奨堕不楽圖	2003	カンヴァスに油彩	73×336cm	木奥惠三	松浦隆広
34	奨堕不楽圖（部分）					
35	絵馬圖	2001	シナベニヤに油彩、ニス	182.5×183cm	木奥惠三	Elizabeth & Reade Griffith
36	悲シクモ不埒ナル目差シノ自画像	2001	カンヴァスに油彩	53.5×46cm 変形額付	宮島 径	宮 誠
37	炎上圖（法隆寺の段）	2001	カンヴァスに墨、油彩	94×134cm	木奥惠三	沼津恒敏
38-39	厩圖	2001	カンヴァスに油彩	74×175cm	木奥惠三	高橋龍太郎
40-41	九相圖	2003	カンヴァスに油彩	73×244cm	木奥惠三	高橋龍太郎
42-43	花圖	2003	カンヴァスに油彩	80.3×197cm	木奥惠三	高橋龍太郎
44	九相圖（部分）／花圖（部分）	——	——	——	——	

頁	作品名	制作年	素材	寸法	撮影者	所蔵者
45	厩圖2004	2004	カンヴァスに水彩、油彩	161×303cm	宮島 径	作家蔵
46-47	中西夏之氏公開制作之圖	2003	カンヴァスに油彩	50×292cm	木奥惠三	作家蔵
48	中西夏之氏公開制作之圖（部分）	──	──	──	──	──
49	東京圖 奘墮不楽乃段（部分）	──	──	──	──	──
50	百貨店圖（日本橋）	1995	麻布に油彩	91×143.4cm	長塚秀人	個人蔵
51	ダクト圖	2001	カンヴァスに油彩	117.5×74cm	木奥惠三	草野千秋
52-53	東京圖 奘墮不楽乃段	2001	紙にペン、水彩	各33×99cm	木奥惠三	高橋龍太郎
54	東京圖 六本木昼圖	2002	紙にペン、水彩	40×63cm	木奥惠三	森アーツセンターミュージアムショップ
55	東京圖 広尾ー六本木	2002	紙にペン、水彩	73.5×65.5cm	木奥惠三	森アーツセンターミュージアムショップ
56	百貨店圖 日本橋三越	2004	紙にペン、水彩	59.4×84.1cm		株式会社 三越
57	百貨店圖 日本橋 新三越本店	2004	紙にペン、水彩	59.4×84.1cm		株式会社 三越
58-59	大阪市電百珍圖	2003	紙にペン、水彩	25×112.5cm		大阪市交通局
60	大阪市電百珍圖（部分）	──	──	──	──	──
61	頼朝像図版写し	1999	カンヴァスに油彩、図録2冊(2点組)	各81×65cm	宮島 径	高橋龍太郎
62	裏表圖	2000	紙に水彩	29.7×11cm	宮島 径	個人蔵
		2000	コピーに水彩	29.7×11cm	宮島 径	個人蔵
63	借景式「當吉地獄圖畫」	2000	カンヴァスに油彩	213×57cm	宮島 径	永山英世
		2000	紙に水彩	22×6.2cm	宮島 径	永山英世
64	「自在絵」見本	2000	紙に水彩	各約20×400cm	宮島 径	高橋龍太郎
65	遠見の頼朝共時性	2000	カンヴァスに油彩	81×65cm	宮島 径	高橋龍太郎
66-67	両洋な目ー階段参詣圖	2001	カンヴァスに油彩	53.5×46cm	木奥惠三	大田黒国彦
		2001	カンヴァスに油彩	53.5×46cm	吉尾正洋	松田 明・恵美子
68	小型化廉価複製「尻馬八艘飛乃段」	2000	カンヴァスに油彩	大65×53cm	宮島 径	個人蔵
		2000	カンヴァスに油彩	小41×32cm	宮島 径	個人蔵
69	文字棚	2001	木、紙、竹	55×36×20cm	木奥惠三	宮 誠
70	携行折畳式喫 茶室	2002	浪板、木、紙、その他	215×88×214cm	木奥惠三	作家蔵
	開く絵	2003	木、紙に鉛筆、水彩	(閉じた状態)9.1×10×0.9cm	木奥惠三	作家蔵
				(開いた状態)9.1×10×4cm		
71	右 無題	2003	紙に鉛筆、水彩	14.5×10cm	木奥惠三	月の庭
	左 変化朝がを乃圖	2003	紙に鉛筆、水彩	14.5×10cm	吉尾正洋	松田 明・恵美子
72-73	門前みち／軍艦	1999	紙に鉛筆	各38×56cm（2枚組）	宮島 径	中村秀子
74-75	右「茶室」メカニカル	2000	紙に鉛筆	59.2×46cm	宮島 径	松田 明・恵美子
	中「多宝塔」メカニカル	2000	紙に鉛筆	59.2×46cm	宮島 径	玉重佐知子
	左「神宮」メカニカル	2000	紙に鉛筆	59.2×46cm	宮島 径	草野千秋
76	右 人体圖（上肢）	2000	紙に鉛筆、水彩	10×15cm	宮島 径	草野千秋
	左 人体圖（上肢）	2000	紙に鉛筆、水彩	10×15cm	宮島 径	草野千秋
77	ビデオ用リモコン／宇宙船	1999	紙に鉛筆	各38×56cm（2枚組）	宮島 径	清水紳一
78	右 馬鹿絵「電柱」	2000	紙に鉛筆	42×29.5cm	宮島 径	Ben Weaver
	左 馬鹿絵「水戸芸術館並ビ乃寿司屋」	2000	紙に鉛筆	42×29.5cm	宮島 径	湯浅祥平
79	洞穴の頼朝	1990	カンヴァスに油彩	116.7×91cm	長塚秀人	作家蔵
80	十字軍	1993	紙にペン	120×90cm	長塚秀人	作家蔵

List of Works

page	Title	Year	Materials	Size	Photo	Collection
1	Weapons and Warriors (Detail)	——	——	——	——	——
2-3	Catalog of Complaints	1995	oil on canvas	91×436.2cm	Kei Miyajima	
4-5	Catalog of Complaints and Resignations: A Man Following Others Blindly	1998	oil on canvas	117.2×549cm	Hideto Nagatsuka	Soraya & Alfred Jollon
6	Catalog of Complaints (Detail)	——	——	——	——	——
7	Catalog of Complaints and Resignations: A Man Following Others Blindly (Detail)	——	——	——	——	——
8-9	Postmodern Silly Battle: Prologue	1999	pencil, oil on canvas	81×390cm	Kei Miyajima	Junya Nishiwaki
10-11	Postmodern Silly Battle	1999	oil on canvas	97×324cm	Kei Miyajima	Ryutaro Takahashi
12	Postmodern Silly Battle (Detail)	——	——	——	——	——
13	Modern Pleasures (Detail)	——	——	——	——	——
14-15	Modern Pleasures	2000	oil on canvas	71×342cm	Kei Miyajima	Ryutaro Takahashi
16-17	People Making Things	2001	oil on canvas	112×372cm	Keizo Kioku	Ryutaro Takahashi
18	People Making Things (Detail)	——	——	——	——	——
19	Weapons and Warriors	1996	pencil, watercolor on paper	170×92cm	Kei Miyajima	Makoto Miya
20-21	Postmodern Silly Battle: Headquarters of the Silly Forces	2001	oil, watercolor on canvas	185×76cm	Hideto Nagatsuka	Ryutaro Takahashi
22	Postmodern Silly Battle: Headquarters of the Silly Forces (Detail)			——		——
23	Staircase of Amusements (Detail)	——	——	——	——	——
24-25	Staircase of Amusements	2002	oil on canvas	91×290cm	Keizo Kioku	Shizuoka Cancer Center
26-27	Five Warriors	2003	Chinese ink on paper	each 170×60cm	Shinichi Sato courtesy: Museum of Contemporary Art, Tokyo	artist collection
28-29	Records of Japanese-Sino War & Japanese-Russo War					
28	General Mishchenko	2002	watercolor on paper	15×10cm		artist collection
	Confucianist	2002	pen, watercolor on paper	12×9.7cm		artist collection
	The 203-Meter Hill	2002	pencil, watercolor on paper	15.3×21cm		artist collection
	Japanese cruiser: Yoshino	2002	pen, watercolor on paper	12.6×29.5cm		artist collection
29	Flagship: Mikasa	2002	pencil, watercolor on paper	28.5×14.9cm		artist collection
	A gun of 28 (centimeter)	2002	pen, watercolor on paper	20.5×18.5cm		artist collection
	French heavy cavalry	2002	pencil, watercolor on paper	10×14.8cm		artist collection
30-31	From the Announcements of NHK's Digital Broadcasting Start					
30	"Celebrate Digital Broadcasting Start"	2003	pen, watercolor on paper	22.8×35.7cm	Keizo Kioku	artist collection
31	"Digital Broadcasting Start"	2003	pen, watercolor on paper	23.4×39.6cm	Keizo Kioku	artist collection
32-33	Sho-Da-Furaku (Show the Flag)	2003	oil on canvas	73×336cm	Keizo Kioku	Takahiro Matsuura
34	Sho-Da-Furaku (Show the Flag) (Detail)	——	——	——	——	——
35	Votive Tablet of a Horse	2001	oil, varnish on plywood	182.5×183cm	Keizo Kioku	Elizabeth & Reade Griffith

page	Title	Year	Materials	Size	Photo	Collection
36	Self-portrait—With Rude Eyes, Contrary to My Expectation	2001	oil on canvas	53.5×46cm (with irregularly shaped frame)	Kei Miyajima	Makoto Miya
37	In Flames (Horyuji)	2001	Chinese ink, oil on canvas	94×134cm	Keizo Kioku	Tsunetoshi Numazu
38-39	Horse Stable	2001	oil on canvas	74×175cm	Keizo Kioku	Ryutaro Takahashi
40-41	The Nine Aspects	2003	oil on canvas	73×244cm	Keizo Kioku	Ryutaro Takahashi
42-43	Flowers	2003	oil on canvas	80.3×197cm	Keizo Kioku	Ryutaro Takahashi
44	The Nine Aspects (Detail) / Flowers (Detail)	——	——	——	——	——
45	Horse Stable 2004	2004	watercolor , oil on canvas	161×303cm	Kei Miyajima	artist collection
46-47	Public Demonstration of Painting by Prof. Natsuyuki Nakanishi	2003	oil on canvas	50×292cm	Keizo Kioku	artist collection
48	Public Demonstration of Painting by Prof. Natsuyuki Nakanishi (Detail)	——	——	——	——	——
49	Tokei (Tokyo): Sho-Da-Furaku (Detail)	——	——	——	——	——
50	Department Store (in Nihonbashi)	1995	oil on canvas	91×143.4cm	Hideto Nagatsuka	private collection
51	Duct City	2001	oil on canvas	117.5×74cm	Keizo Kioku	Chiaki Kusano
52-53	Tokei (Tokyo): Sho-Da-Furaku	2001	pen, watercolor on paper	each 33×99cm	Keizo Kioku	Ryutaro Takahashi
54	Tokei (Tokyo): Roppongi Hills	2002	pen, watercolor on paper	40×63cm	Keizo Kioku	Mori Arts Center Museum Shop
55	Tokei (Tokyo): Hiroo and Roppongi	2002	pen, watercolor on paper	73.5×65.5cm	Keizo Kioku	Mori Arts Center Museum Shop
56	Department Store: Nihonbashi Mitsukoshi	2004	pen, watercolor on paper	59.4×84.1cm		Mitsukoshi Ltd.
57	Department Store: New Nihonbashi Mitsukoshi	2004	pen, watercolor on paper	59.4×84.1cm		Mitsukoshi Ltd.
58-59	One Hundred Unusual Scenes of Osaka Trams	2003	pen, watercolor on paper	25×112.5cm		Osaka Municipal Transportation Bureau
60	One Hundred Unusual Scenes of Osaka Trams (Detail)	——	——	——		
61	Copies of Portrait of Minamoto no Yoritomo	1999	oil on canvas, 2 catalogs (a set of 2)	each 81×65cm	Kei Miyajima	Ryutaro Takahashi
62	Both Sides	2000	watercolor on paper	29.7×11cm	Kei Miyajima	private collection
		2000	photocopy, watercolor on paper	29.7×11cm	Kei Miyajima	private collection
63	"Postmodern Scene of Hell" in Backdrop Style	2000	oil on canvas	213×57cm	Kei Miyajima	Eisei Nagayama
		2000	watercolor on paper	22×6.2cm	Kei Miyajima	Eisei Nagayama
64	"Zizai-E" (Free-standing Pair of Scrolls)	2000	watercolor on paper	each about 20×400cm	Kei Miyajima	Ryutaro Takahashi
65	Portrait of Yoritomo, from a Distance / Concurrence	2000	oil on canvas	81×65cm	Kei Miyajima	Ryutaro Takahashi
66-67	Approach to the Shrine: Eastern and Western Styles	2001	oil on canvas	53.5×46cm	Keizo Kioku	Kunihiko Ohtaguro
		2001	oil on canvas	53.5×46cm	Masahiro Yoshio	Akira & Emiko Matsuda
68	Small and Inexpensive Reproduction, "A Man Following Others Blindly"	2000	oil on canvas	(large) 65×53cm	Kei Miyajima	private collection
		2000	oil on canvas	(small) 41×32cm	Kei Miyajima	private collection
69	Construction in Letters	2001	wood, paper, bamboo	55×36×20cm	Keizo Kioku	Makoto Miya
70	Portable Folding Tea Ceremony Room	2002	corrugated plastic sheet, wood, paper, etc.	215×88×214cm	Keizo Kioku	artist collection
	Unfolding Picture	2003	wood, pencil, watercolor on paper	(closed) 9.1×10×0.9cm (open) 9.1×10×4cm	Keizo Kioku	artist collection

page	Title	Year	Materials	Size	Photo	Collection
71	Untitled	2003	pencil, watercolor on paper	14.5×10cm	Keizo Kioku	Tsuki no Niwa
	Variant Type of Morning Glory	2003	pencil, watercolor on paper	14.5×10cm	Masahiro Yoshio	Akira & Emiko Matsuda
72-73	Temple Street / Warship	1999	pencil on paper	each 38×56cm (a set of 2)	Kei Miyajima	Hideko Nakamura
74-75	"Tea Ceremony Room" Mechanical	2000	pencil on paper	59.2×46cm	Kei Miyajima	Akira & Emiko Matsuda
	"Temple" Mechanical	2000	pencil on paper	59.2×46cm	Kei Miyajima	Sachiko Tamashige
	"Shrine" Mechanical	2000	pencil on paper	59.2×46cm	Kei Miyajima	Chiaki Kusano
76	Human Mechanics	2000	pencil, watercolor on paper	10×15cm	Kei Miyajima	Chiaki Kusano
	Human Mechanics	2000	pencil, watercolor on paper	10×15cm	Kei Miyajima	Chiaki Kusano
77	Video Player Remote Control / Spaceship	1999	pencil on paper	each 38×56cm (a set of 2)	Kei Miyajima	Shinichi Simizu
78	Silly Drawing: Utility Pole	2000	pencil on paper	42×29.5cm	Kei Miyajima	Ben Weaver
	Silly Drawing: Sushi Restaurant Near Art Tower Mito	2000	pencil on paper	42×29.5cm	Kei Miyajima	Shohei Yuasa
79	Minamoto no Yoritomo in the Cave	1990	oil on canvas	116.7×91cm	Hideto Nagatsuka	artist collection
80	Crusade	1993	pen on paper	120×90cm	Hideto Nagatsuka	artist collection

Preface

Akira Yamaguchi

When I was a student at the Tokyo National University of Fine Arts and Music, I attended a lecture by a well-known architect. During the discussion period, I was astounded to hear a student in the music department start her question with the words: "From John Cage onward, we . . ." Well, maybe not astounded, but I certainly felt it was downright cheeky of a mere student to drop the name of this foreign composer—known for an opus consisting of several minutes of complete silence—as if the great master's achievements constituted the basis of her own existence. I have forgotten the content of the question, and what the architect said in reply, but the incident made me begin to think: Did I ever try to put my own work in the context of the history of art? Did I ever try to carry on an inner dialogue with my ancient predecessors? I remember worrying that a mere reference to the history of art, or art itself, might lead to an inflated sense of self-importance disguised as earnestness.

Looking back on it now, I wonder what I was afraid of. Was I confusing self-effacement with purity? Was I viewing the dynamism of culture as something to take for granted?

A misapprehension conceived by chance can inspire a work of excellence; blindly following others and jumping on the horse's back without thinking about the outcome can be liberating. Who knows? Maybe you'll end up grabbing your horse by the neck and making it behave. One professor advised me to "be insolent." Thinking about this tip sometimes stops me in my tracks, and sometimes pushes me on. Like today, when I am tossing off these sentences in a lighthearted way, not even knowing who may read them; tomorrow I may be staggering backwards.

For the time being, I humbly hope the readers of this book will find enjoyment in the works presented here.

"The 'Thief' of Japanese Art": The Suspect, Akira Yamaguchi

Yuji Yamashita*

A local newspaper in Gunma Prefecture, the *Jomo Shinbun*, carried a brief article on June 11, 1998, with the headline "20 Playful pieces by Kiryu artist Yamaguchi to be shown in Tokyo until June 20." The almost reverential mention of Tokyo reveals the longings of the backwater art scene for the capital, but the piece as a whole reminds us that quite recently Akira Yamaguchi was unknown to anyone other than the readers of his hometown paper, who themselves perhaps remembered him only as a boy who had done well in his drawing classes. The article is accompanied by a picture of Yamaguchi, looking somewhat lost as he tries to pose in front of his work, and includes a quote from the artist about his sources and process: "I admire the rigor in Brueghel's work, but I am also attracted to the painting of the Momoyama period, scenes that were often rendered on folding screens or sliding doors. In terms of technique, I suppose one can refine brushwork almost limitlessly, but I don't want my paintings to be stiff or academic. Nor do I want them to be weak due to lack of brush skills. In the end, I suppose I think of technique as a way of securing a space in which to be playful." The comment, made when Yamaguchi was still virtually unknown, is striking for what it reveals about his methods and, for me personally, a satisfying admission that Brueghel lurks somewhere in his past —an influence I had always suspected.

In the last several years, Yamaguchi's reputation has grown rapidly, and his idiosyncratic style has often earned him such misguided and inaccurate epithets as "latter-day Yamato-e painter." Despite its relentlessly playful tone, his work deserves more careful consideration lest future art historians accept these facile labels and miss the importance of Yamaguchi's contribution. I myself have no

* Professor of Art History, Department of Art Studies, Meiji Gakuin University

intention of writing this essay as an "authority on Japanese art," or to make pronouncements such as "This artist is known for a style which cites draws freely from 'Yamato-e' painting convention in its humorous depictions of modern-day Japan." Yamaguchi himself has already lampooned such attempts to pigeonhole him in his one-man exhibition "Yamaguchi-ya Oriennale 2003," where he effectively takes the stereotype and runs with it, showing the absurd extremes to which such fashionable notions lead us.

I don't know anything about the reporter who wrote the piece in the local paper back in 1998, but I do know that, unlike many of his counterparts at larger newspapers, he had the good sense to avoid adding his own evaluations of the art in question, choosing instead to convey the words of the artist himself. By doing so, he has inadvertently left us with an invaluable bit of art history.

The article begins this way: "The first one-man exhibition by Akira Yamaguchi, 28, is currently showing at the Mizuma Art Gallery in Omotesando, Tokyo, through June 20. Yamaguchi, who is from Motojuku-*cho*, Kiryu, and a teaching assistant for painting courses at the Tokyo National University of Fine Arts and Music, held a previous show in his hometown of Kiryu, but the Tokyo show is his first major exhibition." The show reported in the article marked Yamaguchi's solo debut in the art world. The previous year his work had been included as one of four artists in a show curated by Makoto Aida at Mizuma featuring the "Kotatsu School." Yamaguchi attracted only limited attention as one of a number of participants in this show.

It was my personal misfortune to have missed both of these early shows. In fact, it wasn't until the next year, with the exhibition entitled "Shakkei (Backdrop)," that I first became acquainted with Yamaguchi's work. This show also garnered a modest mention in the hometown paper, *Jomo Shinbun*:
"Akira Yamaguchi, an artist from, Kiryu, is holding a unique one-man show at the Mizuma Art Gallery. His work, which depicts present-day Japan in the Yamato-e style, is attracting favorable reviews from gallery goers." The title of teaching assistant has vanished and the favorable reviews have begun to pour in. I added my own when I saw the show.

"Shakkei (Backdrop)" is now five years in the past, but I can recall it quite vividly. Mizuma Art Gallery was a five-minute walk from the Omotesando Subway Station (it has since moved to Nakameguro). As you entered, Yamaguchi's diptych entitled "Copies of Portrait of Minamoto no Yoritomo" [*reproduced on page 61 of this volume*] hung to your left. In front of it was a shelf holding reference books with pictures of the original Yoritomo portrait. The show as a whole made quite an impression, but it's the "Yoritomo Portrait" that stays with me most clearly, perhaps because it was in its presence that day that I first met Yamaguchi himself. Quite coincidentally, I had been doing research on the original portrait that inspired Yamaguchi's painting, and I asked him if he was aware that the painting was actually not of Yoritomo but of someone else. In other words, for our first meeting I opted to play the role of art history expert. It seems that Yamaguchi had created his work by visually collating his impressions of two radically different reproductions of the original portrait, one a faded print from a well-known art tome, "*Genshoku Nihon no Bijutsu*" published by Shogakkan, which is now over forty years old, and the other from a more recent exhibition catalog.

That day, as I studied his two paintings, which are effectively reconciliations in oils of the two different photographic reproductions, a rather miraculous transformation occurred in color. The original painting seemed to have undergone a restoration during the time between the publication of those two books, rendering the background design of Yoritomo's kimono more vivid in the newer publication. The difference in the exposure time between the two photographs created two reproductions that gave quite different impressions. At the same time, I could see the evidence of Yamaguchi's Kotatsu School technique as he meditated on the gap between the competing reproductions, capturing that disparity in the exactitude of his brushwork. Perhaps my own experience as a young art scholar put me in sympathy with the approach represented by this painting. As I had sat at my own *kotatsu* table, warming myself as I pored over reproductions of art works, I was often struck by the inadequacy of those very reproductions, the excessive distance between them and their originals. Yamaguchi's work is not an attempt at simulation but a form of "simulationism" that recognizes in its process that very distance.

But my opening line to Yamaguchi that day took a different tack. "By the way," I asked him, "did you know that the man in the portrait isn't actually

Yoritomo?" The question had to do with a little-known debate that was then raging in art history circles. In 1995 Michio Yonekura had just published a book, *Minamoto no Yoritomo Zo, Chinmoku no Shozoga* (Heibon-sha), in which he argued that the famous portrait of Yoritomo was actually Ashikaga Tadayoshi and thus not from the twelfth but from the fourteenth century. Yonekura's theory caused a sensation in the art world, but the day he published it happened to be the same day that the Aum cult released sarin gas in the Tokyo subway system. What might have been a minor cultural note at best was completely lost in the chaos of the moment. Among the few of us who did take note, most critics tended to reject the reassessment. I had been one of the few who actively supported Yonekura, publishing a number of articles on the subject during that period including the book *Reception of Japanese Art in the 20th Century* (Shobunsha, 2003). By an odd coincidence, this copy of a copy of a fake became the occasion for my acquaintance with Akira Yamaguchi and his work.

I wanted to buy Yamaguchi's piece. The price was around 600,000 yen. But the day I visited the gallery it already bore a red "SOLD" sticker. It still annoys me that I missed the chance to get it.

Five years later, I came across "Copies of Portrait of Minamoto no Yoritomo" in the Shiga Museum of Modern Art. It bore the spirited subtitle "From Duchamp, through Warhol, to Morimura." This was the same portrait I had so admired and wanted to obtain. The credit list said it was owned by Dr. Ryutaro Takahashi. Dr. Takahashi is a psychiatrist and collector who is always outsmarting me by buying the pieces I want—for example, Makoto Aida's "Air Raid on New York City" and "Beautiful Flag". As a collector, I find it frustrating.

A recent Yamaguchi painting, "Horse Stable 2004," [*see page 45 of this volume*] was exhibited in the "The Copy Age" show. The exhibition catalog included a photograph of a painting at the Tokyo National Museum entitled "The Stable" on which Yamaguchi's work is based. Stables were a popular motif from the Muromachi to the early Edo periods, and a few dozen examples of these paintings have survived. It would seem that Yamaguchi had studied several of them, including the one at the National Museum, and then "incubated" the various images under the heat of his *kotatsu* warmer, as is his habit. The result a series of "Sights In and Around Kyoto" pieces inspired by the genre painting of the early modern period and yet somehow transcending it. The transcendence comes, I think, through the extraordinary breadth of Yamaguchi's influences, which range from the ukiyo-e of Hokusai and classical paintings such as the "Garden Party" on the Souou-ji folding screen to temple votive pictures, paintings of hell, and martial painting. In every instance, however, he selects images according to individual taste rather than some thematic prescription—a fact worth emphasizing for the benefit of some of Yamaguchi's contemporaries.

Akira Yamaguchi utilizes the subjective category of "taste" to select—some might say "steal"—from the entire range of Japanese art, and then the thief, ensconced at his *kotatsu* table, distills the essence of his "loot." His tastes also take him beyond the confines of native art history or art itself, encompassing Breughel, Reiji Matsumoto's classic anime *Space Battleship Yamato*, and even the literature of Ryotaro Shiba and Tatsuhiko Shibusawa. All of this is ultimately filtered through his unique artistic sensibility onto his complex and compelling canvases. His reputation has, accordingly, enjoyed a meteoric rise in the past few years, with the works in his annual show at Mizuma selling out almost before the doors open. He participates regularly in prestigious group exhibitions such as "Department Store of Contemporary Art" in 2000 and "New Edition! Japanese Art" in 2002, both mounted by the Yamanashi Prefectural Museum, and "Where do I come from? Where am I going?" in 2004 at the Tokyo Museum of Contemporary Art. In addition, his playful rendering of the new Roppongi Hills complex as a classical screen painting [*see pages 54, 55 of this volume*] has become an icon at Roppongi Hills, and he is at work on a similar project for the centennial of the famed flagship Mitsukoshi Department Store in Nihonbashi.

He also illustrated two of the five volumes in Tatsuhiko Shibusawa's series of "Horror Draconia Stories for Girls" (Heibonsha, 2003-04), on which I wrote an essay. I was amazed at his illustrations: Shibusawa, I thought, must be laughing in his grave. This summer the original artworks will be exhibited at the gallery of the NADiff Bookstore in Omotesando, and I will be giving a public talk with Yamaguchi during the show.

Illustration is, of course, regularly denigrated by critics as somehow separate from and inferior to the fine arts and contemporary arts; yet I find myself compelled to point out Yamaguchi's enormous talents as an illustrator, on par with those of Kiyokata Kaburagi. When his work on Ryotaro Shiba's *Clouds Over the Hills*, long kept from the public eye by a copyright dispute, finally comes to light, those talents will be even more evident.

So now, six years after that initial article in the *Jomo Shinbun* from Gunma, the nameless painter from Kiryu has become an art world celebrity. The January issue of *Bijutsu Techo* identifies Yamaguchi as one of the giants of contemporary painting and quotes as follows from his dialogue with fellow artist Makoto Aida:

"Hokusai is of ten said to be the 'pride of Japan.' But in fact the French took up Hokusai and praised him to get back at the English, who made much of the Kano School of art (though perhaps I'm remembering it incorrectly . . . [laughing]). I once gave some thought to where Hokusai came from. Perhaps we Japanese prefer such *kitsch* as works of the Utagawa School, and artists like Hokusai appeal more to Westerners. It seems to me that the history of Japanese art was often influenced by Western viewpoints; I've been realizing that all over again. Art that I thought was 100% foreign in origin may contain something of Japan; and vice versa."

In this dialogue the "thief" confesses to the full range of his masterful appropriations, both domestic and foreign.

This book is the first published collection of his art, and while it's difficult to capture the full impact of his work in reduced format, it gives an excellent sense of his virtuoso technique and endless visual inventiveness—and with any luck it will send the reader running off to the gallery for a first-hand look.

July 14, 2004

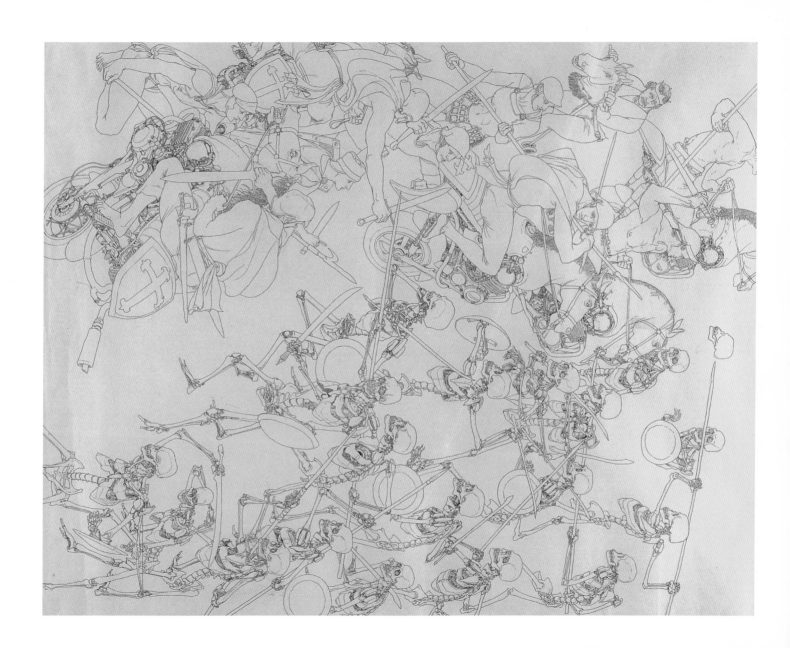

大学3年の頃の絵です。さほど昔でも無いのですが、
当時は此方云った趣味的な絵を描く事が、とてもはばかられる様な気が致しました。

十字軍 1993 紙にペン 120×90cm
Crusade 1993 pen on paper 120×90cm

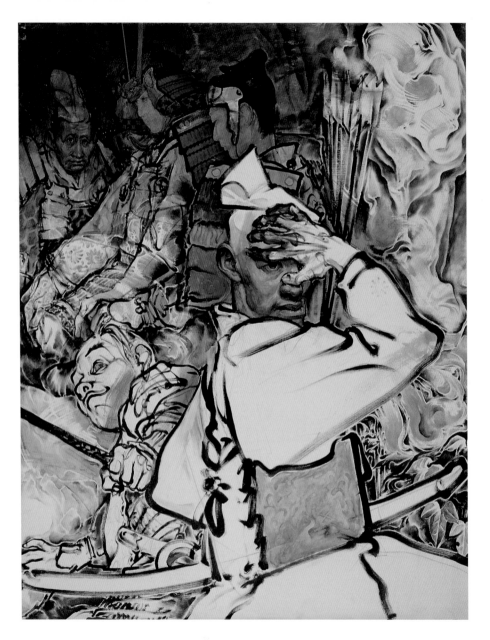

洋の東西の美術史をふまへて
きばって描いたつもりでしたが、
先生方のあきれた様な困り顔は
今も忘れられません。

洞穴の頼朝 1990 カンヴァスに油彩
116.7×91cm
Minamoto no Yoritomo in the Cave
1990 oil on canvas 116.7×91cm

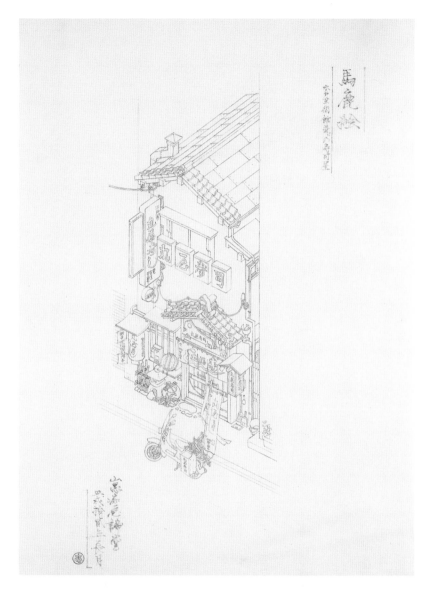

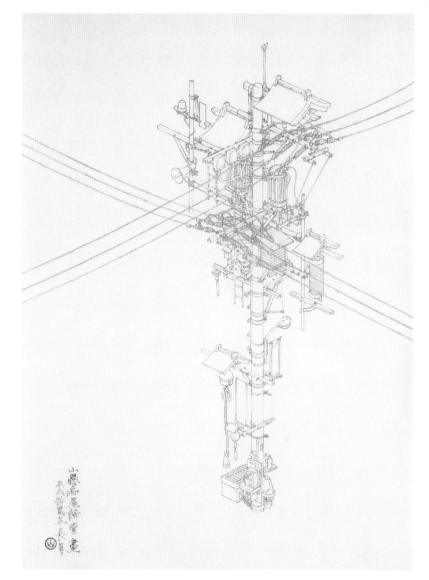

題名の「馬鹿」は私にではなく「絵」にかかっています。
そう云う事にさせて下さい。

馬鹿絵「電柱」 2000 紙に鉛筆 42×29.5cm
馬鹿絵「水戸芸術館並ビ乃寿司屋」2000 紙に鉛筆 42×29.5cm

Silly Drawing: Utility Pole 2000 pencil on paper 42×29.5cm
Silly Drawing: Sushi Restaurant Near Art Tower Mito 2000 pencil on paper 42×29.5cm

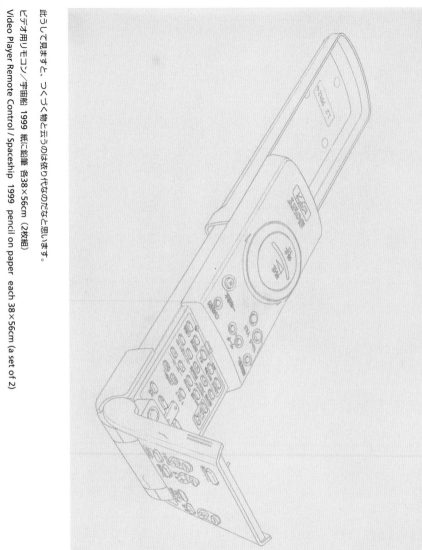

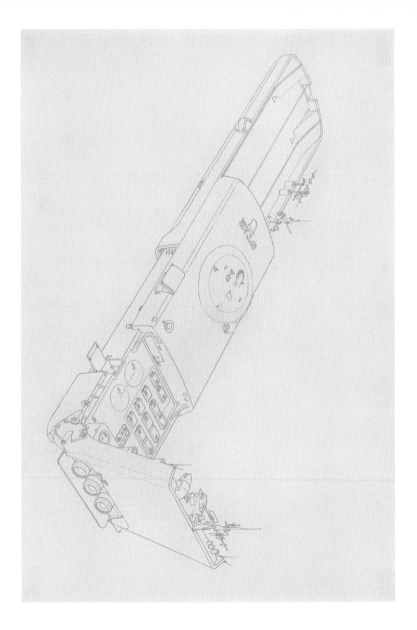

こうして見ますと、つくづく物と云うのは依り代なのだなと思います。

ビデオ用リモコン／宇宙船 1999 紙に鉛筆 各38×56cm（2枚組）

Video Player Remote Control / Spaceship 1999 pencil on paper each 38×56cm (a set of 2)

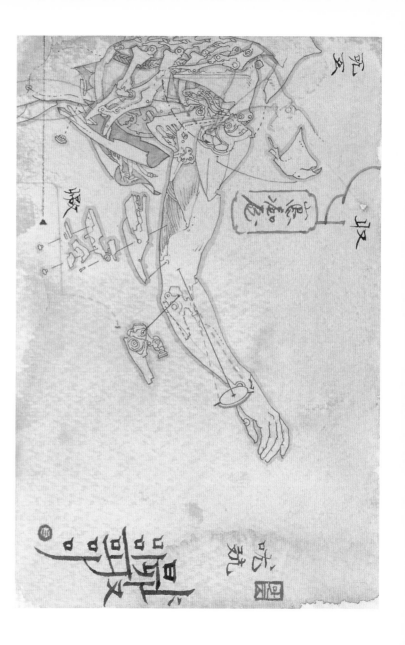

学生の頃は此んな落描きを多くしました。

人体圖（上肢）2000　紙に鉛筆、水彩　10×15cm
人体圖（上肢）2000　紙に鉛筆、水彩　10×15cm
Human Mechanics 2000　pencil, watercolor on paper 10×15cm
Human Mechanics 2000　pencil, watercolor on paper 10×15cm

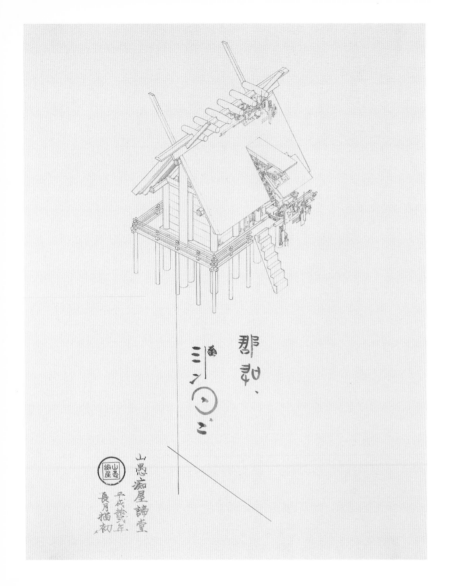

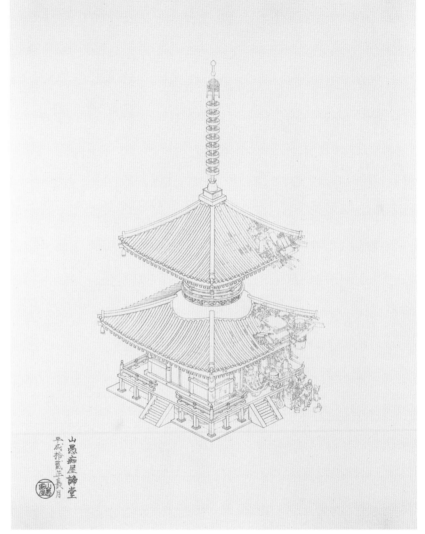

山愚痴屋諦堂　平成拾弐年長月

山愚痴屋諦堂　平成拾弐年長月摘初

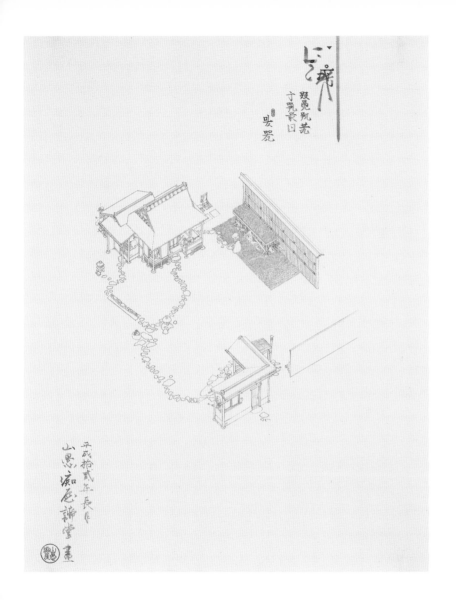

マンガチックと云へばそうですが、収まり処は一緒かもしれません。

右 「茶室」メカニカル 2000 紙に鉛筆 59.2×46cm
中 「多宝塔」メカニカル 2000 紙に鉛筆 59.2×46cm
左 「神宮」メカニカル 2000 紙に鉛筆 59.2×46cm
"Tea Ceremony Room" Mechanical 2000 pencil on paper 59.2×46cm
"Temple" Mechanical 2000 pencil on paper 59.2×46cm
"Shrine" Mechanical 2000 pencil on paper 59.2×46cm

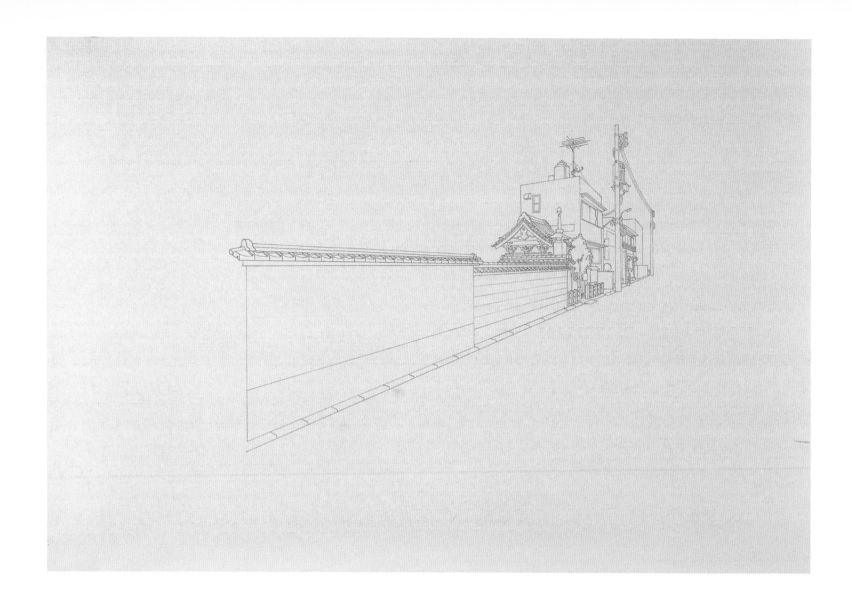

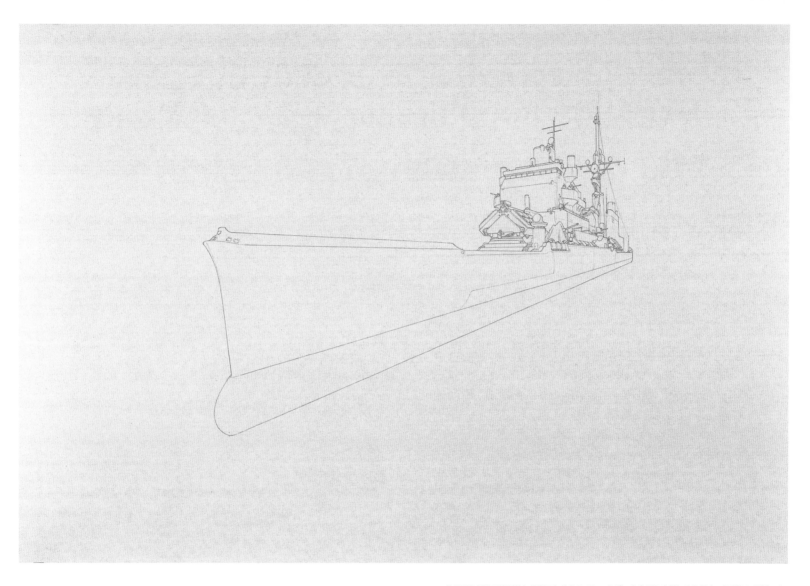

此う云う見立ては子供なら誰でもやるのでしょうが、大人が無自覚にやる見立てはどうも面倒です。

門前みち／軍艦　1999　紙に鉛筆　各38×56cm（2枚組）
Temple Street / Warship　1999　pencil on paper　each 38×56cm (a set of 2)

ド
ロ
ー
イ
ン
グ

Drawings

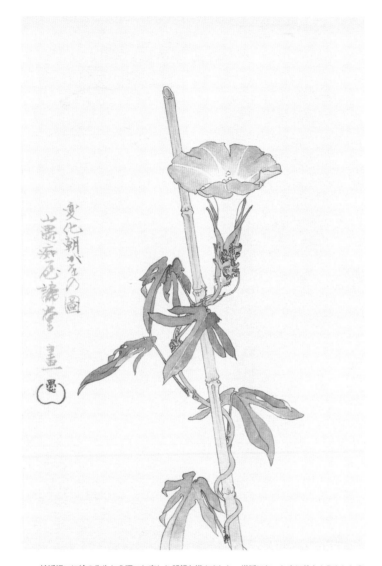

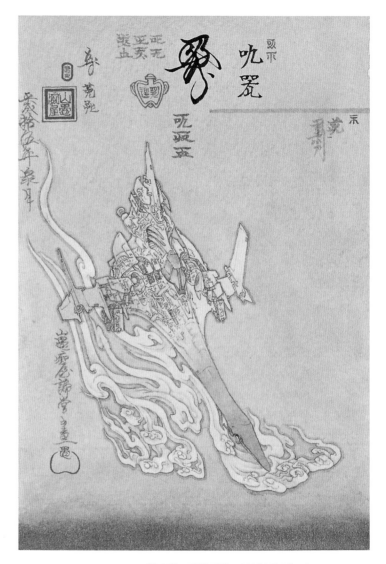

結婚祝いに絵の先生から頂いた変わり朝顔を描きました。世話になった方に差上ようとしたら、
女房に止められ売りに回されました。「もう半分」の奥さんを思い出しました。

変化朝がを乃圖 2003 紙に鉛筆、水彩 14.5×10cm
Variant Type of Morning Glory 2003 pencil, watercolor on paper 14.5×10cm

描いておって気楽で楽しいのは此れ位の絵です。

無題 2003 紙に鉛筆、水彩 14.5×10cm
Untitled 2003 pencil, watercolor on paper 14.5×10cm

71

気分としては「きれいさび」なのですが。

携行折畳式喫 茶室 2002
浪板、木、紙、その他 215×88×214cm
Portable Folding Tea Ceremony Room 2002
corrugated plastic sheet, wood, paper, etc.
215×88×214cm

手なぐさみとは此の事です。

開く絵 2003 木、紙に鉛筆、水彩
（閉じた状態）9.1×10×0.9cm
（開いた状態）9.1×10×4cm
Unfolding Picture 2003
wood, pencil, watercolor on paper
(closed) 9.1×10×0.9cm
(open) 9.1×10×4cm

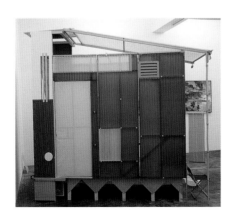

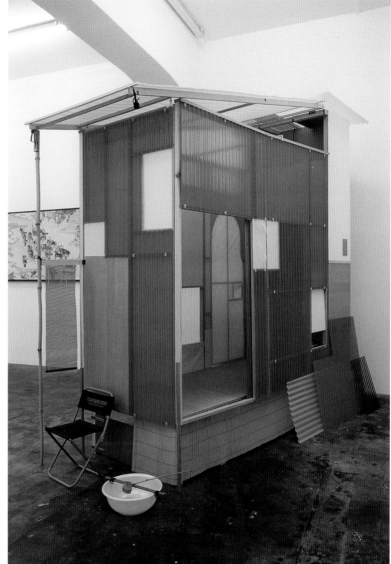

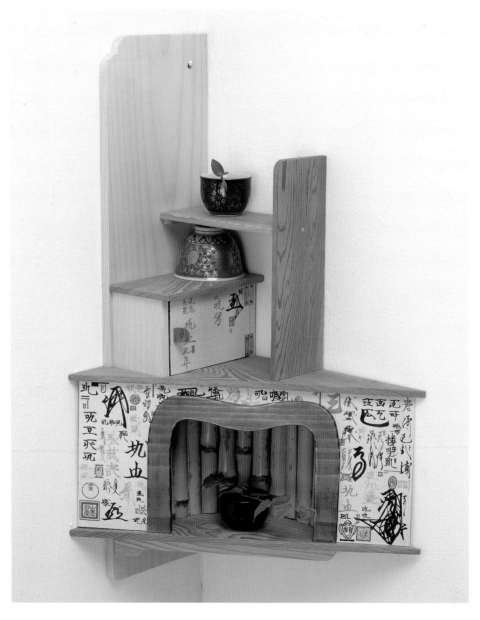

「楽しい工作」気分で作りました。
一応絵描きのつもりでおりますので、
実に気楽にやりました。
白光りするネジが好いでしょう。

文字棚 2001 木、紙、竹 55×36×20cm
Construction in Letters 2001
wood, paper, bamboo 55×36×20cm

◀ 山愚痴諦抄―尻馬八艘飛乃段　第一面（4頁）　約7.5分の1縮尺
Catalog of Complaints and Resignations: A Man Following Others Blindly
the first panel (p.4) scale of about 1:7.5

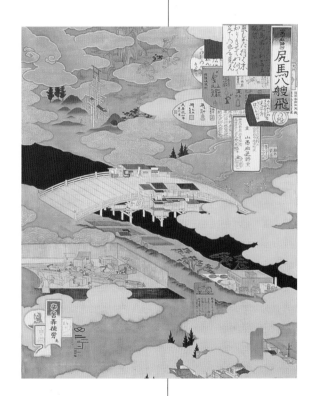

「自分を模倣しだしたらおしまいだ」と或る教授がおっしゃっていたのを聞いて、閃きました。

小型化廉価複製「尻馬八艘飛乃段」　2000　カンヴァスに油彩　大65×53cm　小41×32cm
Small and Inexpensive Reproduction, "A Man Following Others Blindly"
2000 oil on canvas 65×53cm / 41×32cm

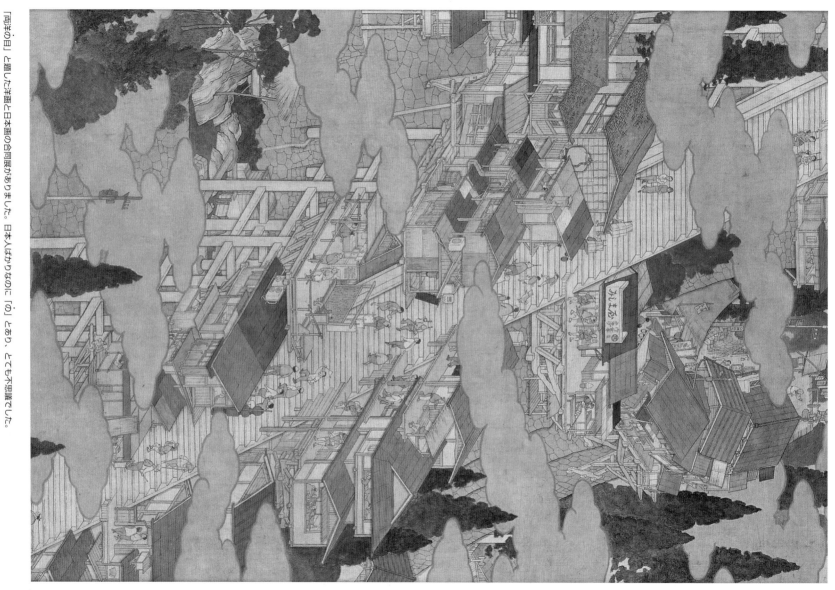

両洋な目　一階段参詣図　2001　カンヴァスに油彩　各53.5×46cm
Approach to the Shrine: Eastern and Western Styles　2001　oil on canvas　each 53.5×46cm

「両洋の目」と題した洋画と日本画の合同展がありました。日本人ばかりなのに「め」とあり、とても不思議でした。

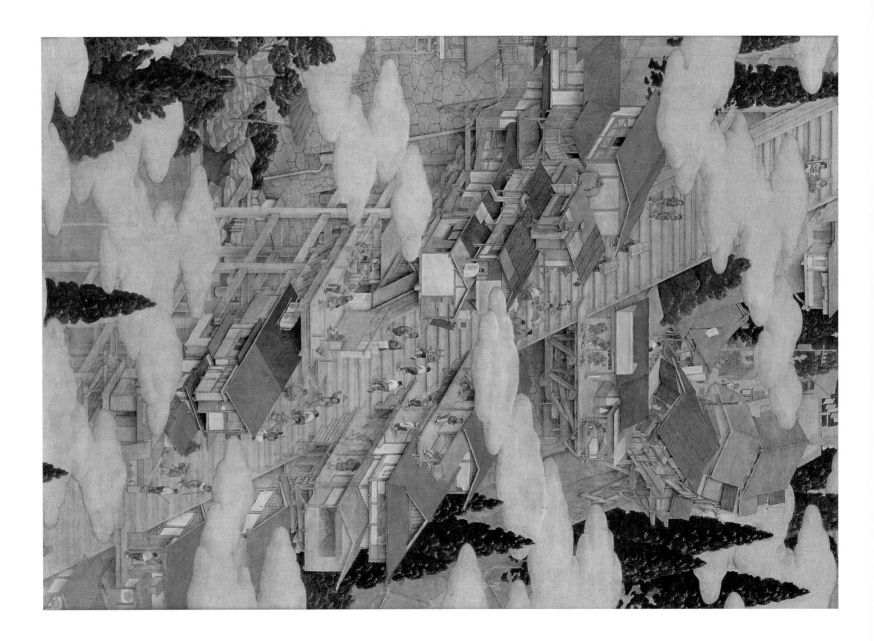

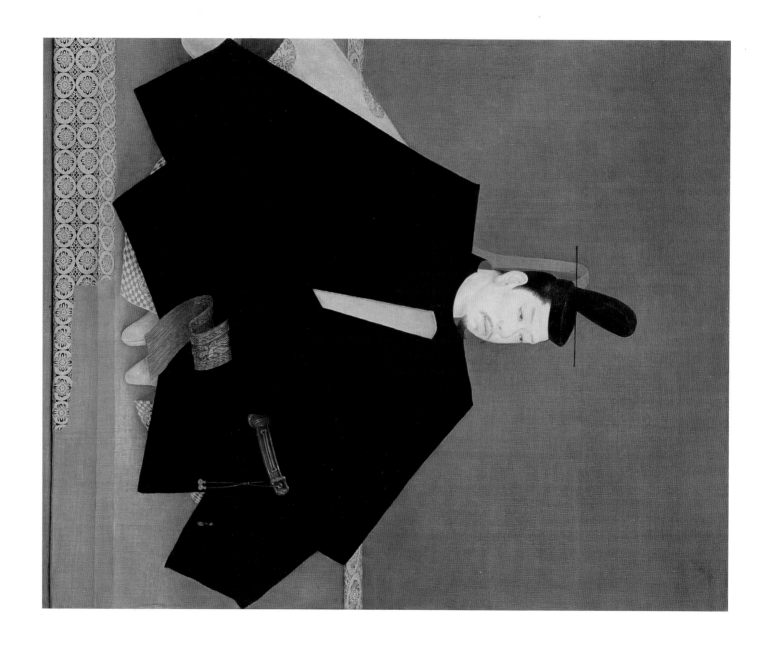

小さな図版の「伝頼朝像」を見てあるとホルバインの肖像画を想う事があります。
インキの照りもその一因かと思います。

遠見の頼朝共時性 2000 カンヴァスに油彩 81×65cm

Portrait of Yoritomo, from a Distance / Concurrence 2000 oil on canvas 81×65cm

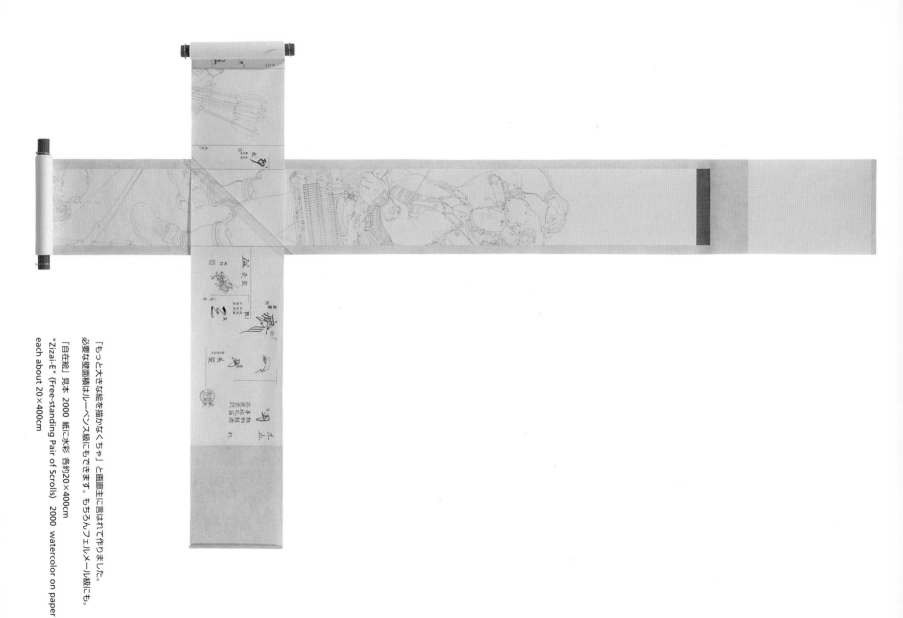

「もっと大きな絵を描かなくちゃ」と画廊主に言はれて作りました。
必要な壁面積はルーベンス級にもできます。もちろんフェルメール級にも。

【自在絵】見本 2000 紙に水彩 各約20×400cm
"Zizai-E" (Free-standing Pair of Scrolls) 2000 watercolor on paper
each about 20×400cm

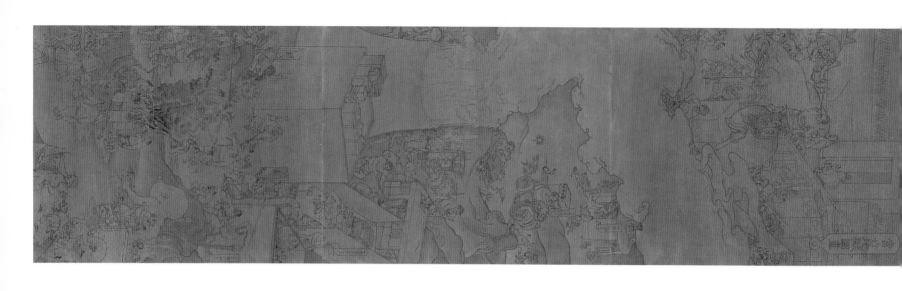

「イメージの在り家」みた様な事をテーマにしたのでしょうか。
よく憶えていません。
小図を描き込んだ大図にイメージをほぶふさせるという
省エネ絵画の一つでもありました。
大小が見た目上同じ大きさに見える場所から鑑賞する様になっています。
此れはその第二弾で、「逆の方が面白いのに」という
お客の声にしたがったものです。手間がかかりました。

借景式「當古地獄圖畫」2000
カンヴァスに油彩 213×57cm ／ 紙に水彩 22×6.2cm
"Postmodern Scene of Hell" in Backdrop Style 2000
oil on canvas 213×57cm / watercolor on paper 22×6.2cm

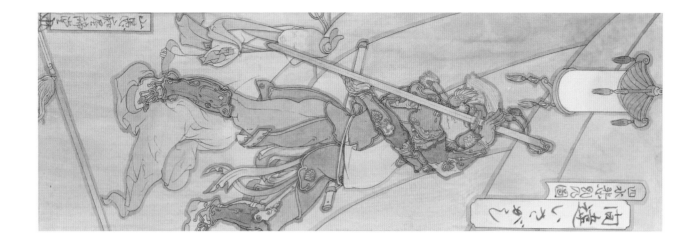

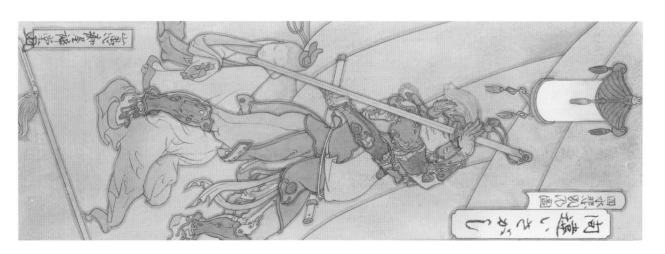

展示の際は、2枚を同時に見られぬ様、裏表にしました。
図に異なった点はないので、「なし」と云うのが答へです。
裏表図　2000　紙に水彩／コピーに水彩　各29.7×11cm
Both Sides　2000　watercolor on paper / photocopy, watercolor on paper　each 29.7×11cm

コンセプチュアル風

In the Style of Conceptual Art

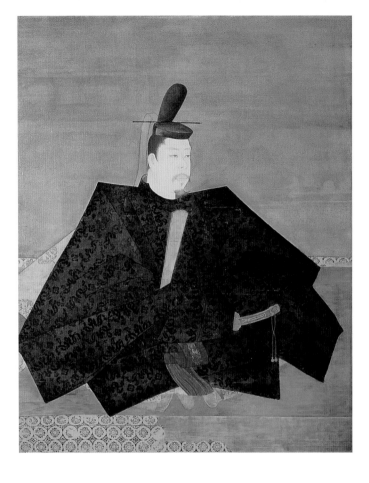 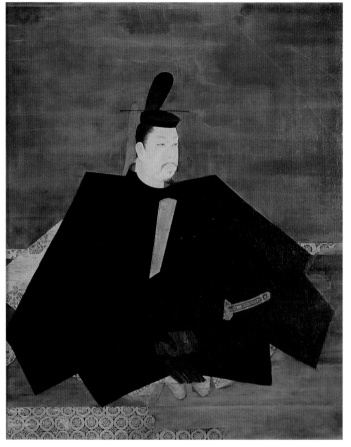

実物を見た時の落胆が発端です。「俺の憧れを返せ」と云う事の他に、
図版が修復前後のものと云う事で違う意味がかぶってきてしまいました。

頼朝像図版写し　1999　カンヴァスに油彩、図録2冊（2点組）　各81×65cm
Copies of Portrait of Minamoto no Yoritomo 1999 oil on canvas, 2 catalogs (a set of 2) each 81×65cm

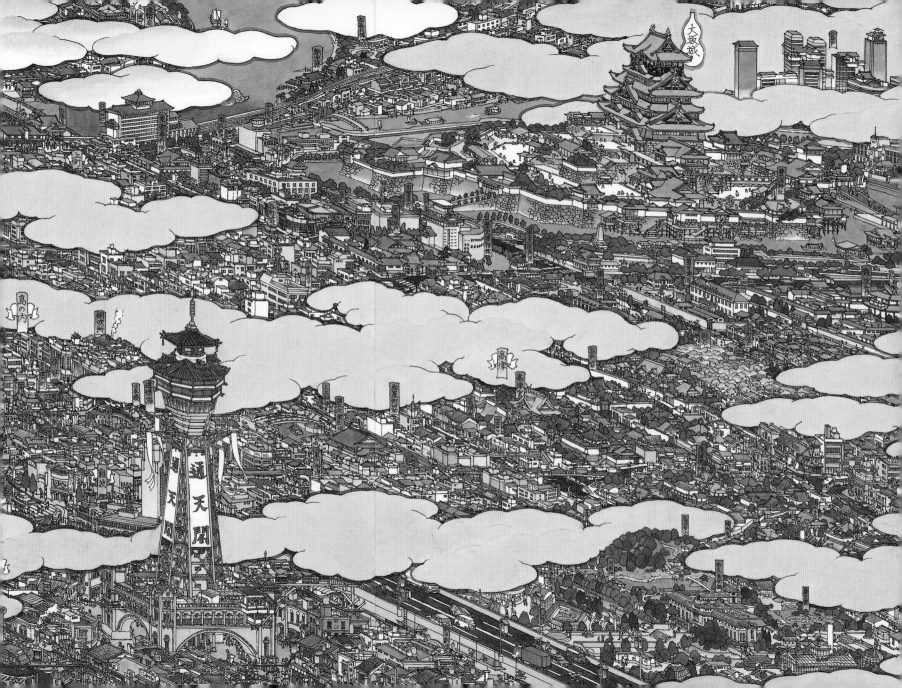

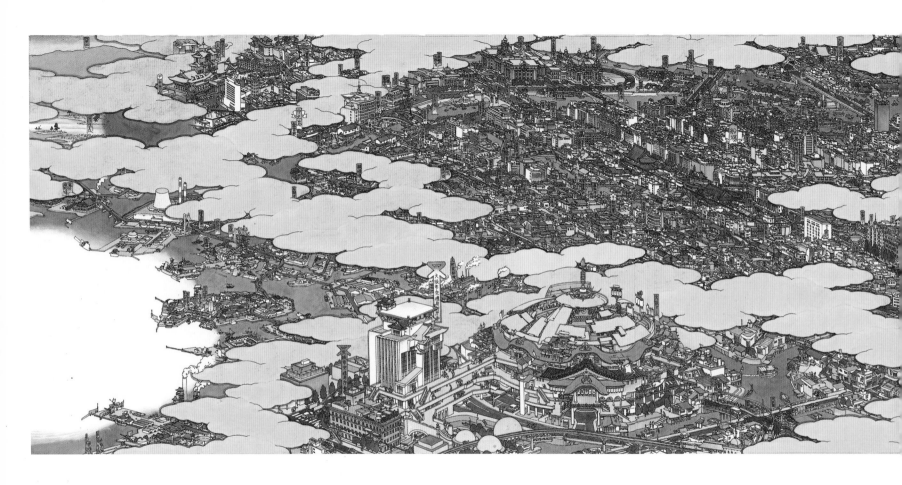

◀ 大阪市電百珍圖 （部分）
One Hundred Unusual Scenes of Osaka Trams (Detail)

59

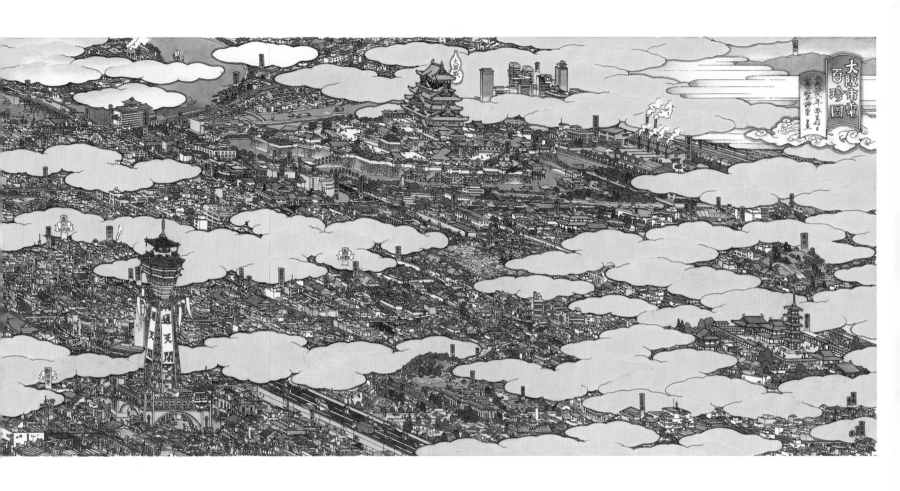

此れを描く為に大阪には相当詳しくなりました。大いばりで「何でもきいて」と
女房に云うに、「素敵なバーは何処？」ときかれ絶句しました。女なんて。

大阪市電百珍圖 2003 紙にペン、水彩 25×112.5cm
One Hundred Unusual Scenes of Osaka Trams 2003 pen, watercolor on paper 25×112.5cm

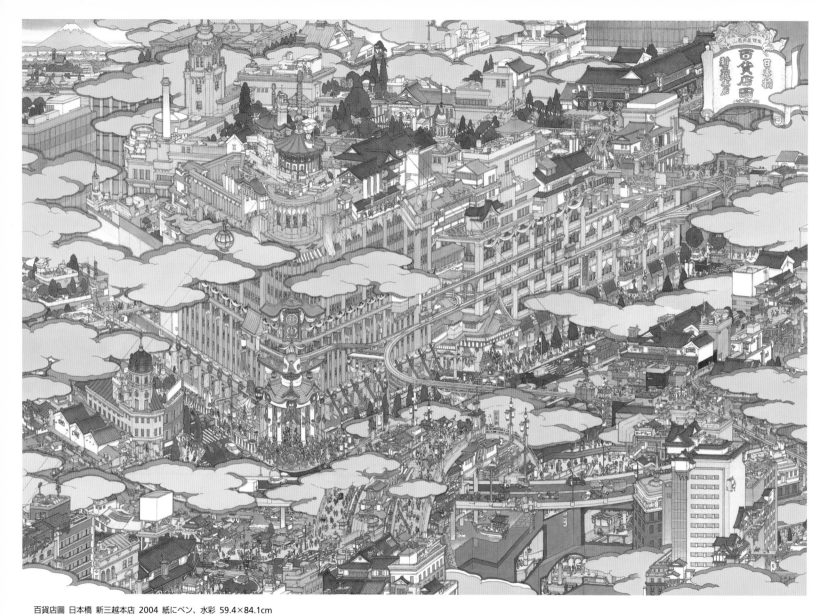

百貨店圖　日本橋　新三越本店　2004　紙にペン、水彩　59.4×84.1cm
Department Store: New Nihonbashi Mitsukoshi 2004　pen, watercolor on paper　59.4×84.1cm

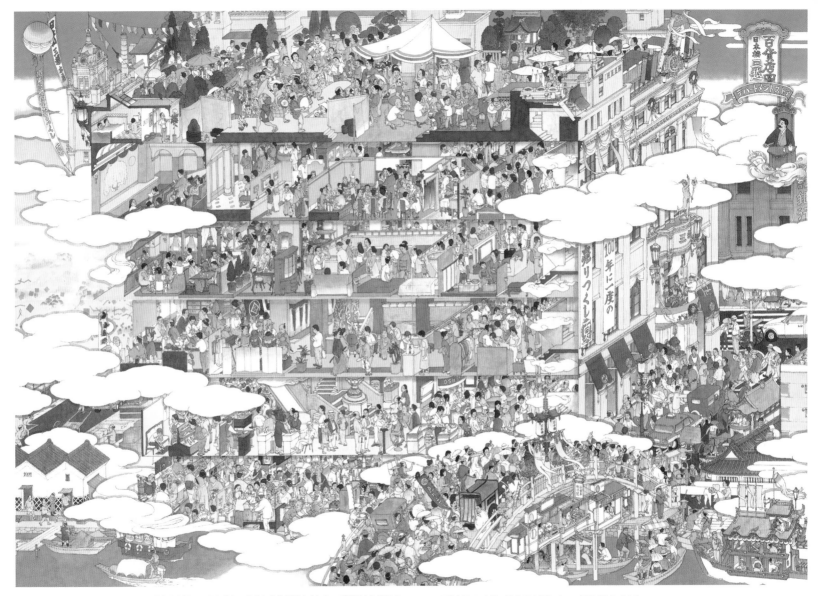

百貨店圖を描いてより十年、本物から依頼がきました。感慨ひとしほです。

百貨店圖 日本橋三越 2004 紙にペン、水彩 59.4×84.1cm
Department Store: Nihonbashi Mitsukoshi 2004 pen, watercolor on paper 59.4×84.1cm

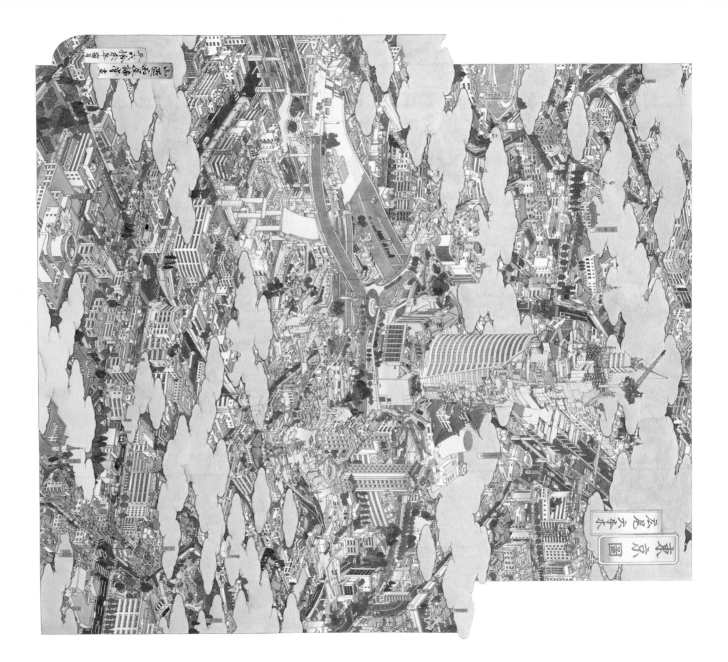

此の辺りで生まれたので思い入れがあります。思い出の風景は殆ど無くなってしまいました。一寸懐かしさもこもった絵です。古絵図を見る愉しみを見つけられたのが収穫でしょうか。

東京圖 広尾―六本木 2002 紙にペン、水彩 73.5×65.5cm

Tokei (Tokyo): Hiroo and Roppongi 2002 pen, watercolor on paper 73.5×65.5cm

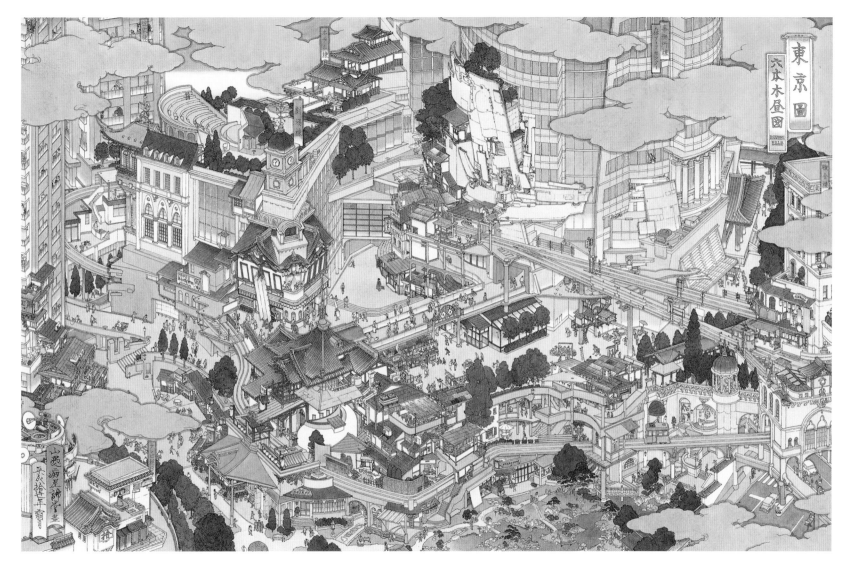

実に注文に応へた、職業画家然とした絵に思います。どうぞ御注文ください。
東京圖 六本木昼圖 2002 紙にペン、水彩 40×63cm
Tokei (Tokyo): Roppongi Hills 2002 pen, watercolor on paper 40×63cm

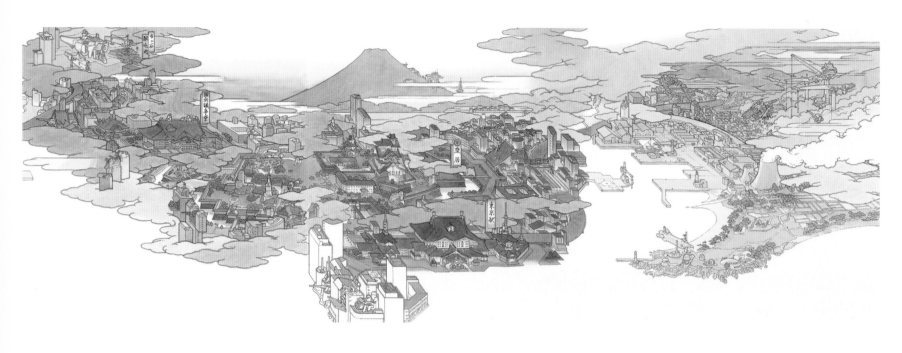

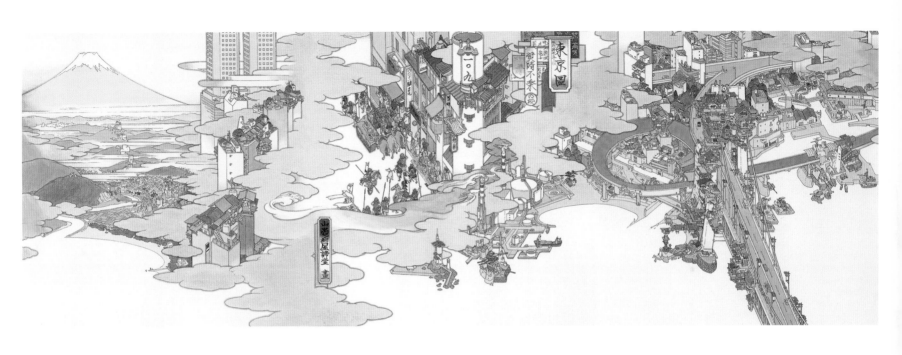

妙な話ですが、幼い僕には東京と云うのは外国そのものでありました。
後年、初めて欧州の地を踏んだ時の落胆は、其の為でしょうか。
げに実際と実感のありかこそ、知るべしです。

東京圖 奨堕不楽乃段 2001 紙にペン、水彩 各33×99cm
Tokei (Tokyo): Sho-Da-Furaku 2001 pen, watercolor on paper each 33×99cm

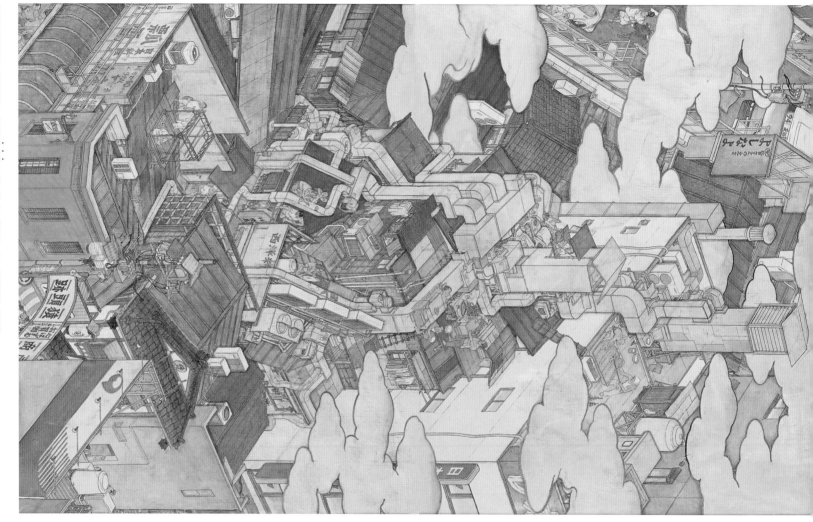

ダクト図 2001 カンヴァスに油彩 117.5×74cm
Duct City 2001 oil on canvas 117.5×74cm

北千住の駅前あたりを参考に、心持ちくどくしてみました。画中ホームレスが登場しますが、「弱者への視点」なんぞではなく、「祟りを恐れて」と言った方が正しいでしょう

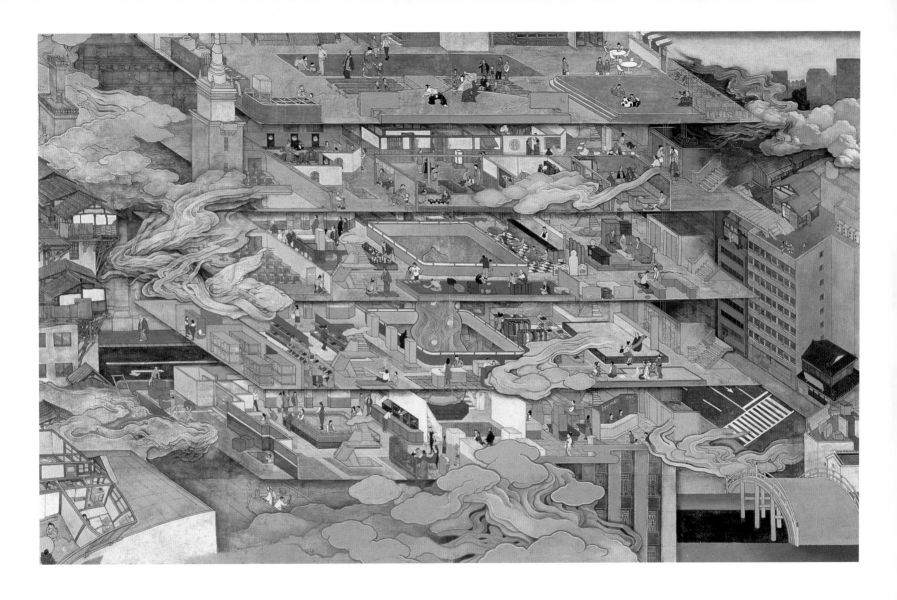

昇降機は断絶した断面としての各階を見せゆきます。　百貨店圖（日本橋）1995 麻布に油彩 91×143.4cm
屋上庭園はその哀しさを噛みしめる場所です。　Department Store (in Nihonbashi) 1995 oil on canvas 91×143.4cm

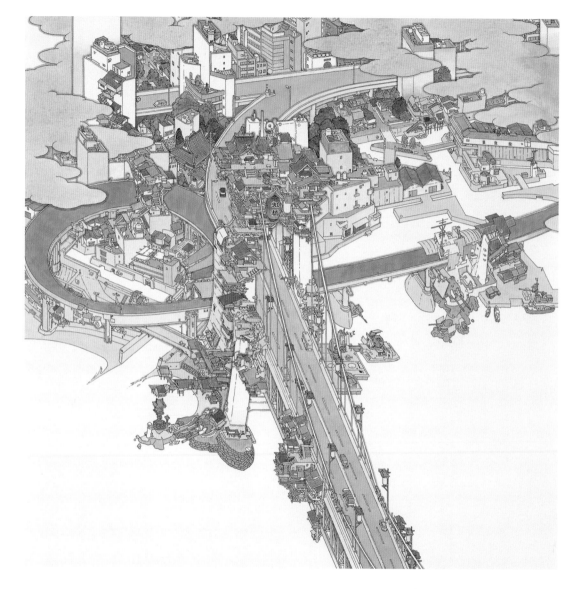

東京圖 奨堕不楽乃段（部分）
Tokei (Tokyo): Sho-Da-Furaku (Detail)

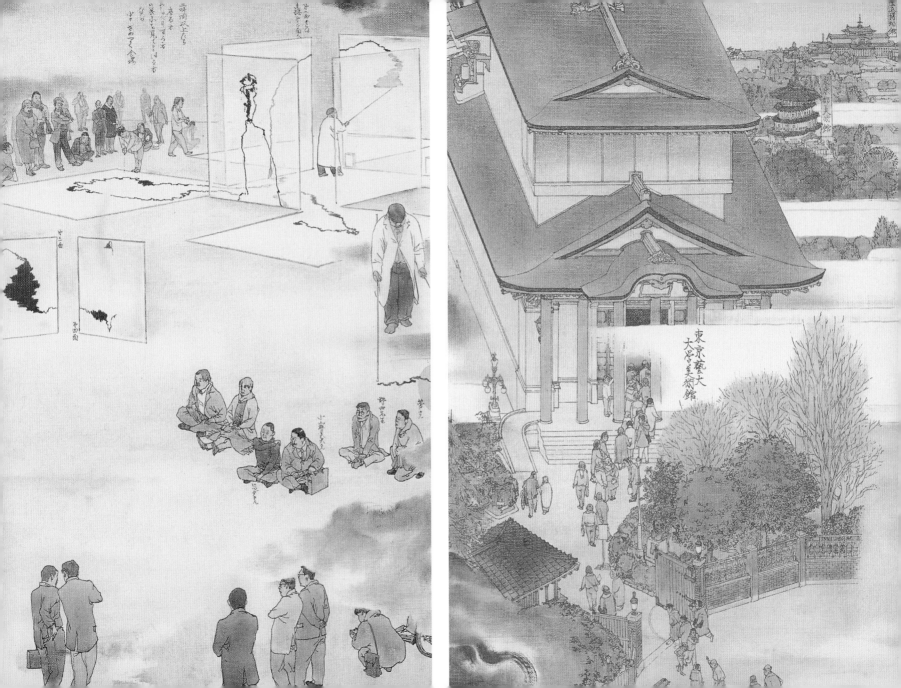

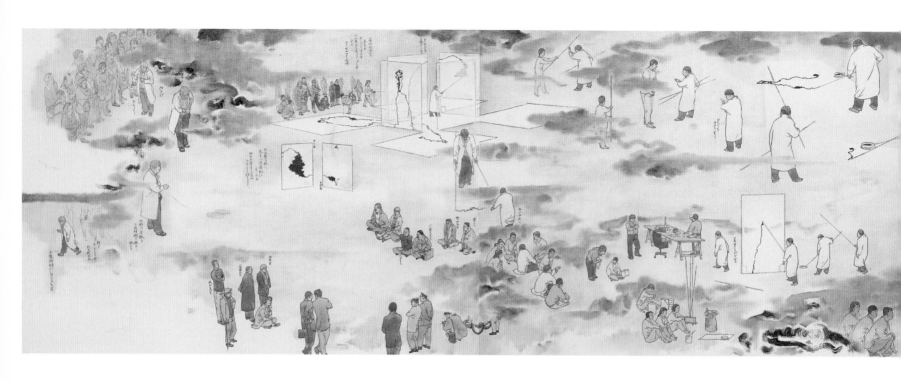

◀ 中西夏之氏公開制作之圖（部分）
Public Demonstration of Painting by Prof. Natsuyuki Nakanishi (Detail)

47

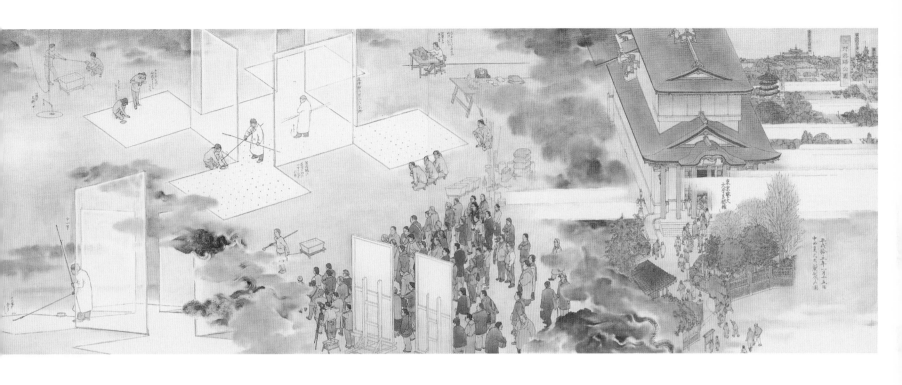

私[わたくし]は確かに其処におりました。

中西夏之氏公開制作之圖　2003　カンヴァスに油彩　50×292cm
Public Demonstration of Painting by Prof. Natsuyuki Nakanishi　2003
oil on canvas　50×292cm

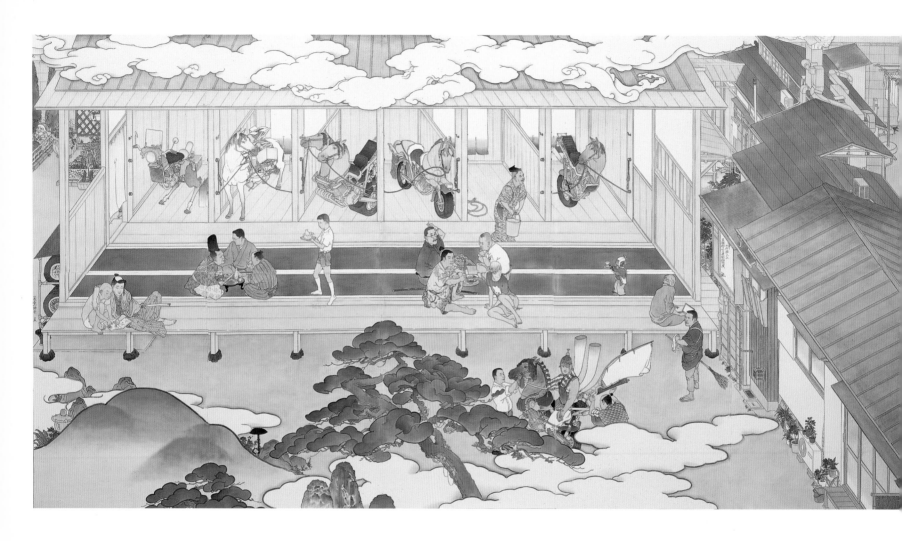

引け目を感じながらも、依頼があれば再び此んな絵を描いてしまいます。
職業画家と云うのでしょうか……。

厩圖2004 2004 カンヴァスに水彩、油彩 161×303cm
Horse Stable 2004 2004 watercolor, oil on canvas 161×303cm

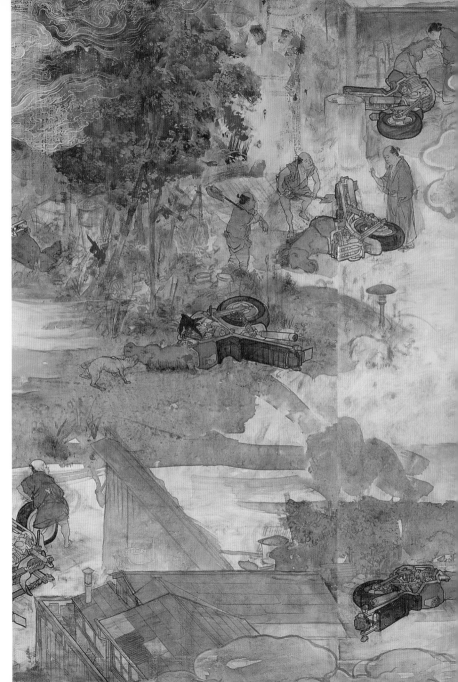

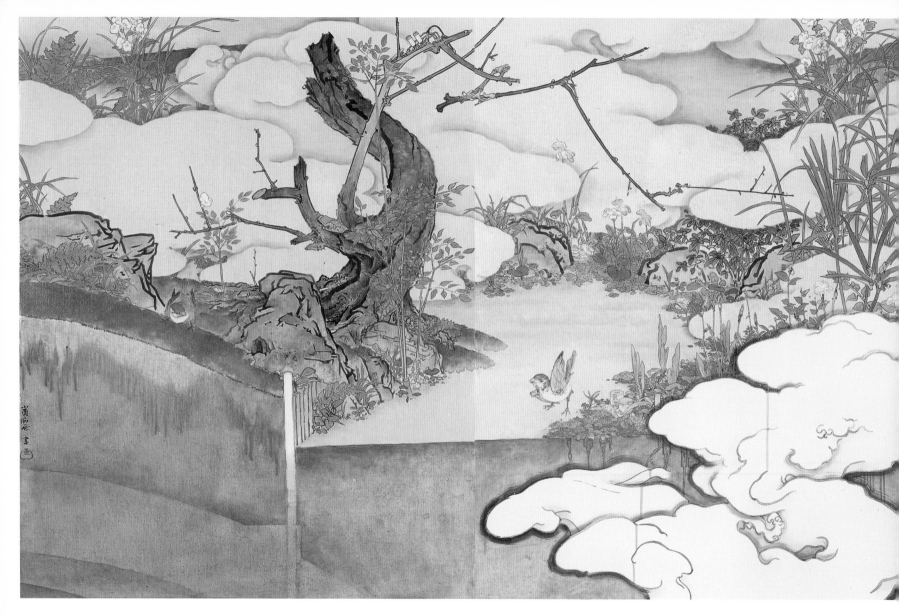

◀ 九相圖（部分）／花圖（部分）　The Nine Aspects (Detail) / Flowers (Detail)

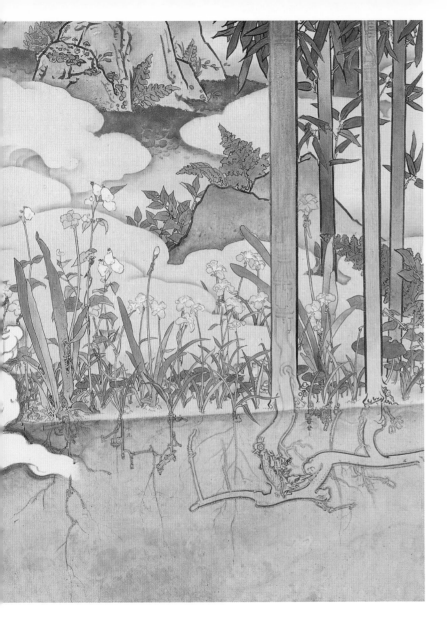

断面と云う表面は内部では無いから可視な訳です。
終わりの無い金太郎飴、多分あそこも金太郎……。

花圖 2003 カンヴァスに油彩 80.3×197cm
Flowers 2003 oil on canvas 80.3×197cm

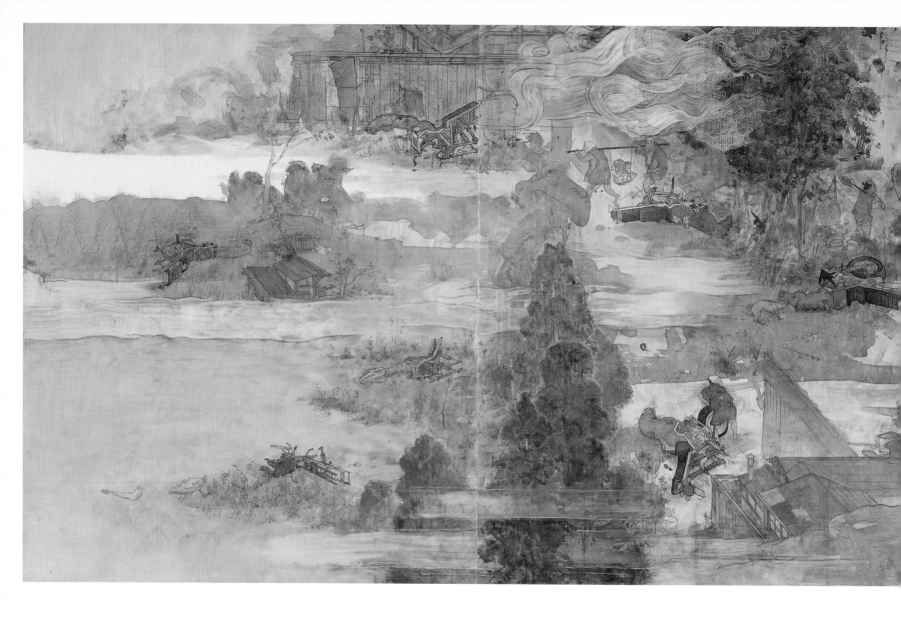

41

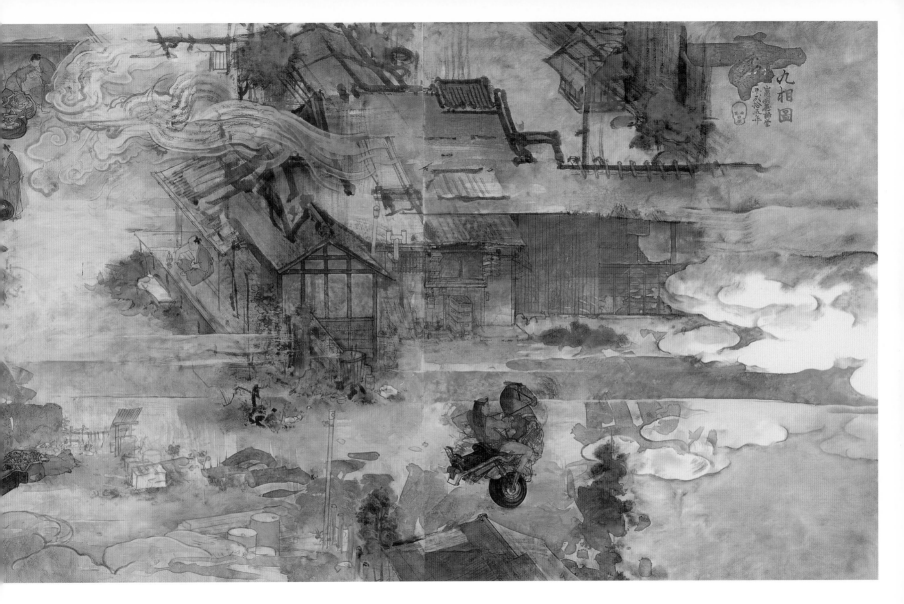

人間から見ればビーバーの巣や蟻塚も自然の一部ですから、
誰かさんから見ればビルヂングやオートバイも其の仲間かも知れません。

九相圖 2003 カンヴァスに油彩 73×244cm
The Nine Aspects 2003 oil on canvas 73×244cm

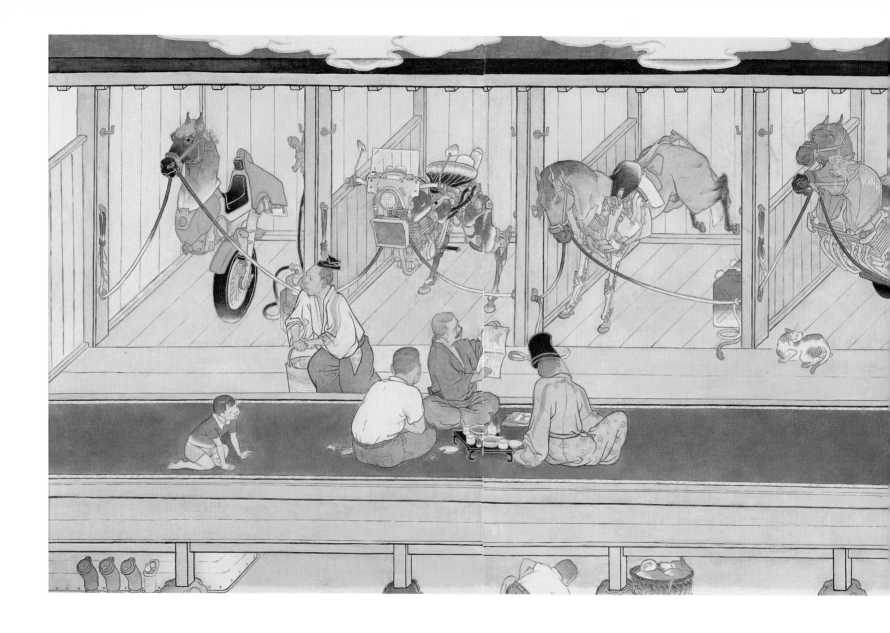

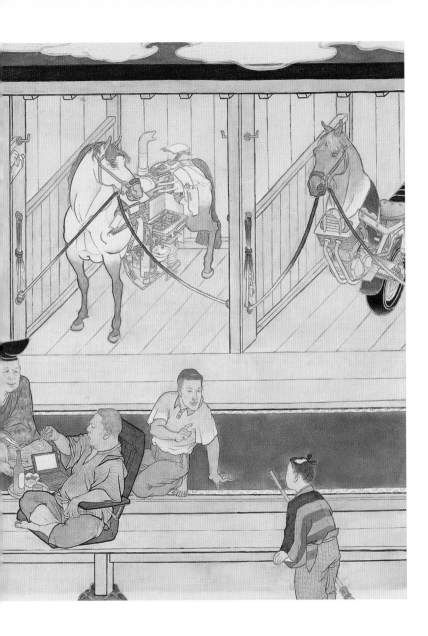

節操なく絵を描いておりますが、此の絵にはちと引け目を感じます。
何となれば、あまりにも「古典の引用」風だからです。

厩圖 2001 カンヴァスに油彩 74×175cm
Horse Stable 2001 oil on canvas 74×175cm

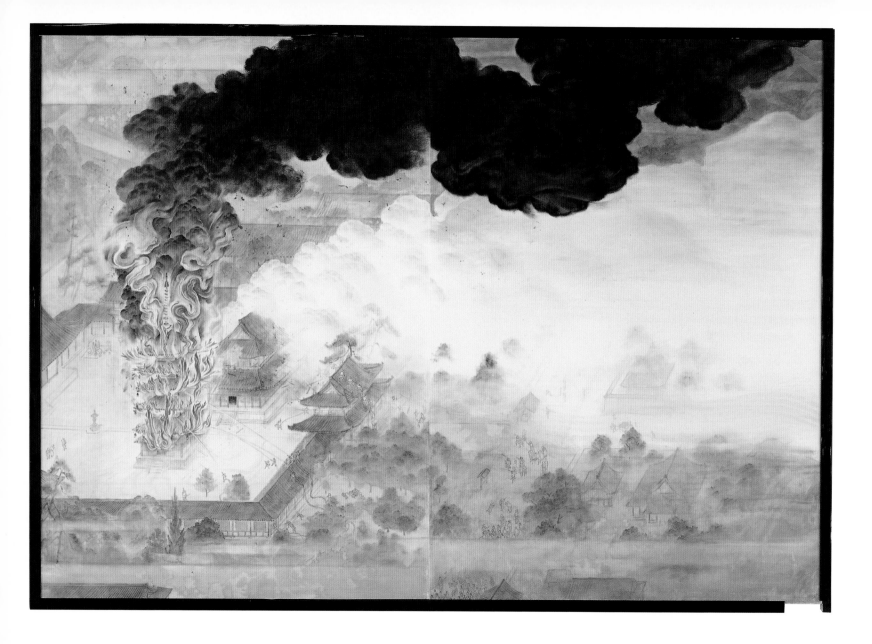

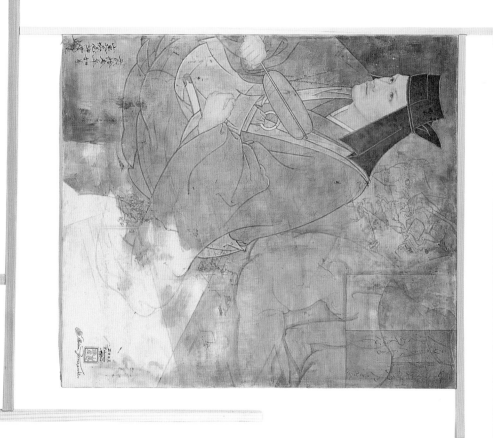

「悲シク哭ク不如帰」なと言い訳して中途半端な絵を描いておる訳ですが、
言い訳は＜みあげ湯葉の如く、大体を保留してしまいます。

悲シク哭ク不如帰ナル目差シ／自画像 2001 カンヴァスに油彩 53.5×46cm 変形額付
Self-portrait—With Rude Eyes, Contrary to My Expectation 2001
oil on canvas 53.5×46cm (with irregularly shaped frame)

▼
若冲の絵に鶏冠の朱以外、墨で描いた頭があります。
ほゞモノクロなのにカラーの印象を受けました。省エネ絵画の一ツです。
炎上図（法隆寺の段）2001 カンヴァスに墨、油彩 94×134cm
In Flames (Horyuji) 2001 Chinese ink, oil on canvas 94×134cm

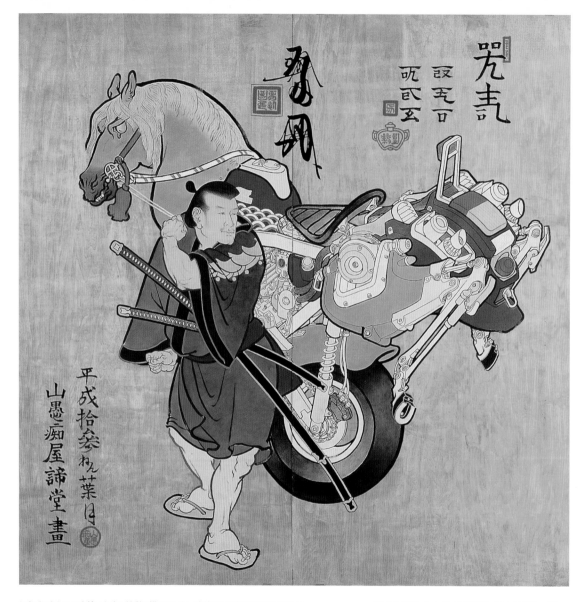

「大和絵」風

Yamato-e Re-created

シナベニヤにニスを塗った上に油彩で描きました。奉納された古い大絵馬を見ると、
色彩はすっかりとんでしまって板だけが閑全としています。此の絵はその逆になるでしょう。

絵馬圖 2001 シナベニヤに油彩、ニス 182.5×183cm
Votive Tablet of a Horse 2001 oil, varnish on plywood 182.5×183cm

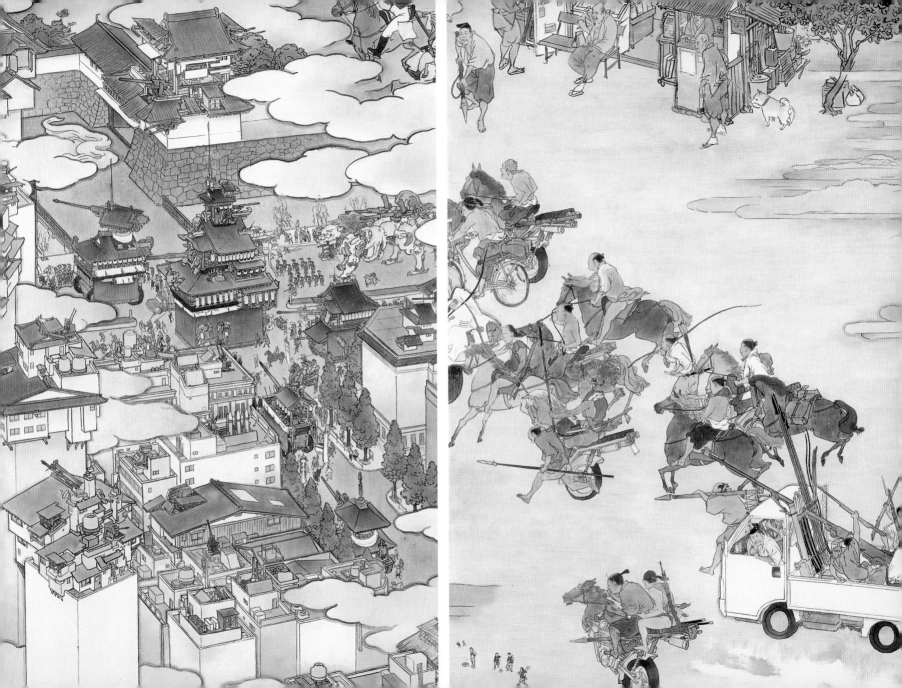

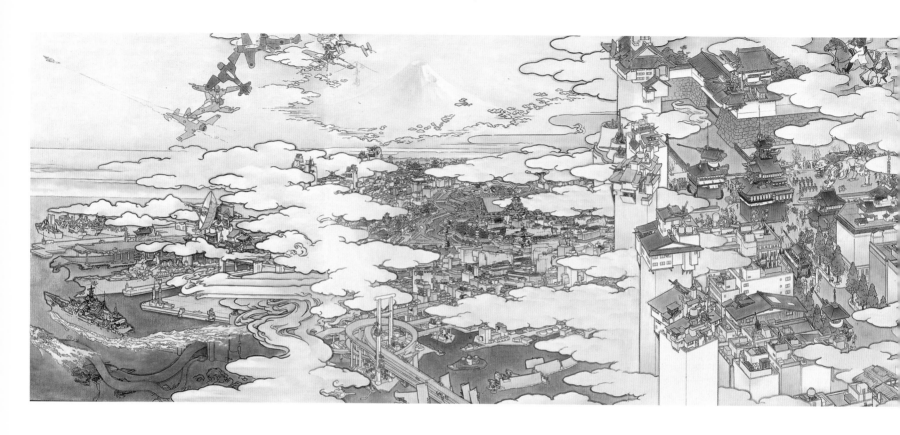

◀ 奨堕不楽圖（部分）
Sho-Da-Furaku (Show the Flag) (Detail)

33

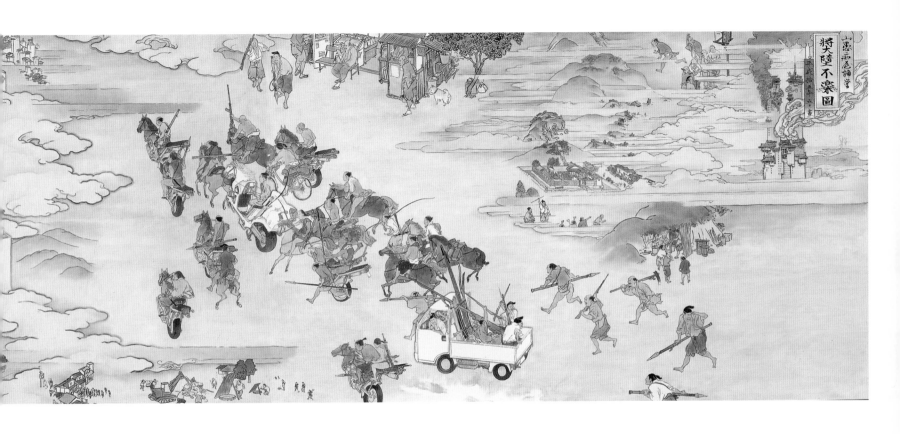

題名は「ショーザフラッグ」のもじりですが、画中炎上する建物は都庁です。

奨堕不楽圖 2003 カンヴァスに油彩 73×336cm
Sho-Da-Furaku (Show the Flag) 2003 oil on canvas 73×336cm

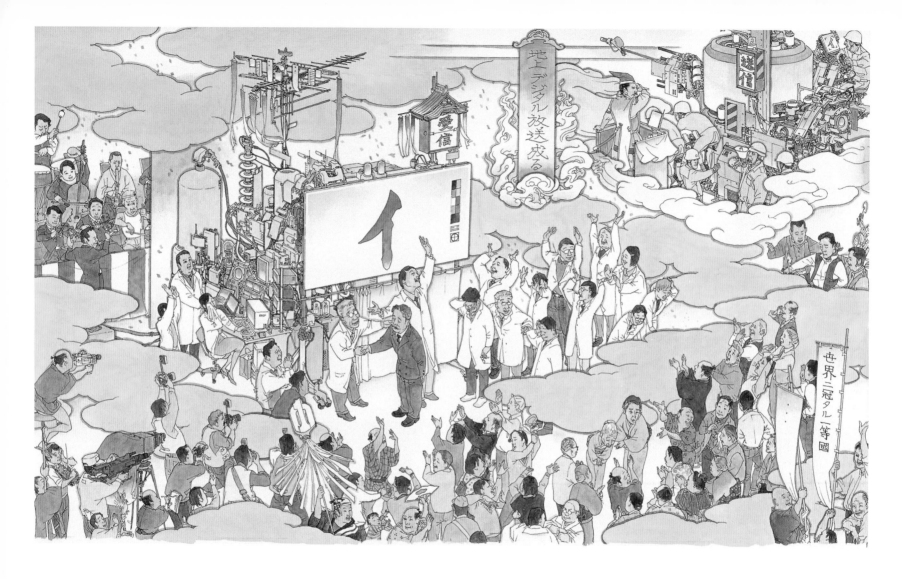

「地上デジタル放送成る」 2003 紙にペン、水彩 23.4×39.6cm
"Digital Broadcasting Start" 2003 pen, watercolor on paper 23.4×39.6cm

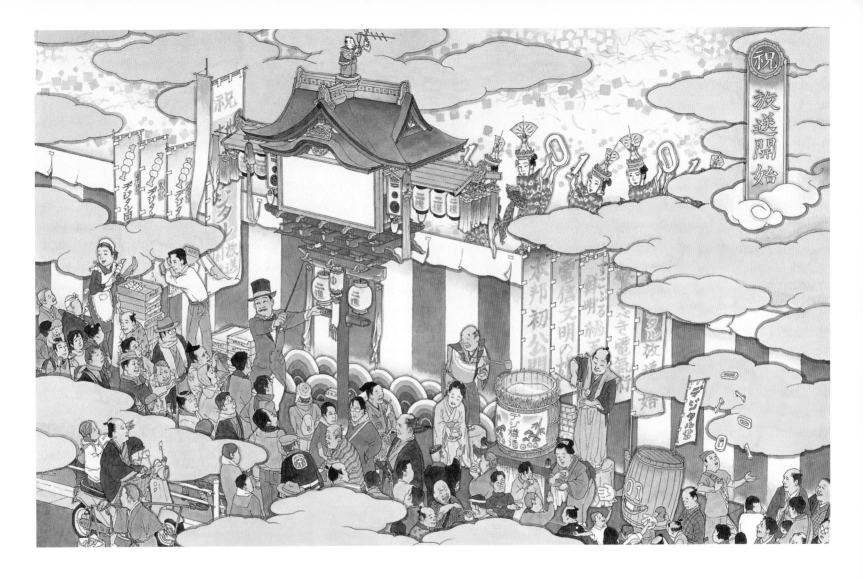

注文を受けてする仕事は、一ぱしの職業人気取りができる反面、
自分ののらくらさをつきつけられもします。

NHKデジタル放送開始告知番組の為の原画より
From the Announcements of NHK's Digital Broadcasting Start
「祝 放送開始」 2003 紙にペン、水彩 22.8×35.7cm
"Celebrate Digital Broadcasting Start" 2003 pen, watercolor on paper 22.8×35.7cm

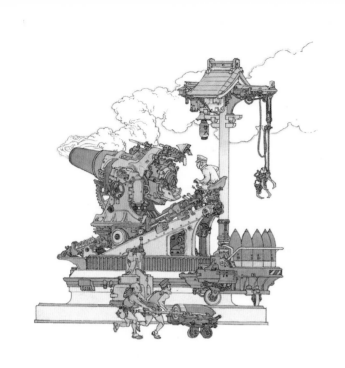

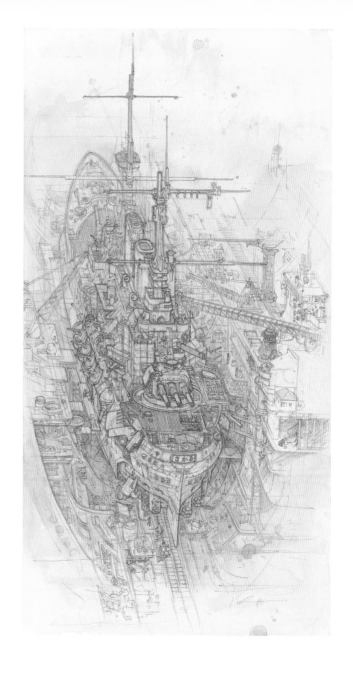

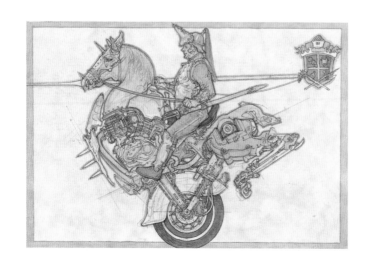

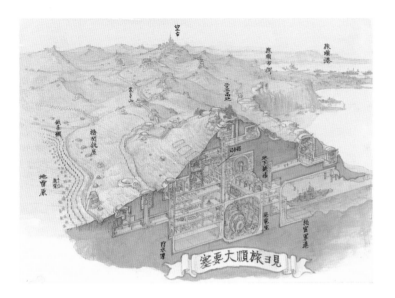

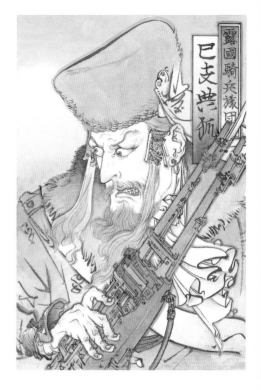

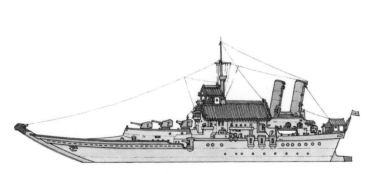

『坂の上の雲』が下敷きです。
其れなりに考へてあって、本文の抜粋コピーをベタベタと
はりつけておったのですが、全て却下。
戦争画になってしまいました。

「日清日露戦役擬畫」より
2002（紙にペン、鉛筆、水彩）
Records of Japanese-Sino War & Japanese-Russo War
2002（pen, pencil, watercolor on paper)
ミシチェンコ少将　General Mishchenko　15×10cm
儒者　Confucianist　12×9.7cm
二〇三高地　The 203-Meter Hill　15.3×21cm
日本巡洋艦 吉野　Japanese cruiser: Yoshino　12.6×29.5cm
旗艦 三笠　Flagship: Mikasa　28.5×14.9cm
二十八サンチ砲　A gun of 28 (centimeter)　20.5×18.5cm
フランス重騎兵　French heavy cavalry　10×14.8cm

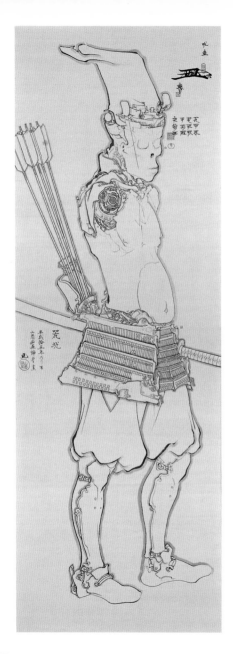

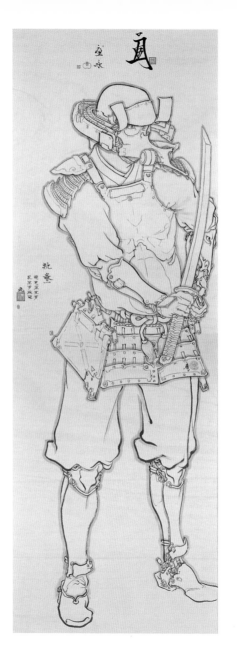

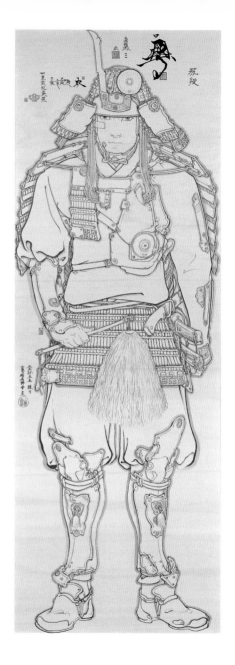

27

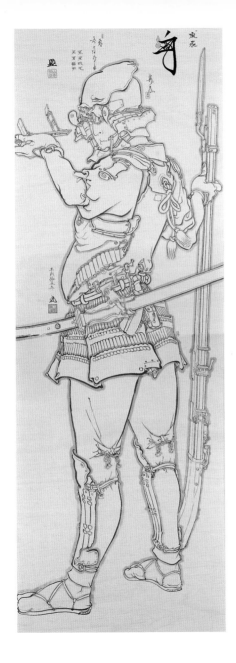

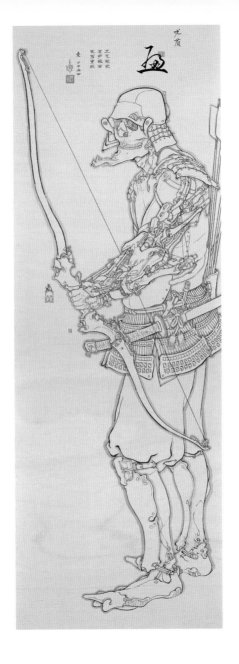

普段はハガキ大に描いている此んな絵を、随分前芸大の同級生に
「等身大でやってみたら」と言はれ実行してみました。
岡目八目とでも云いましょうか。

五武人圖 2003 紙に墨 各170×60cm
Five Warriors 2003 Chinese ink on paper each 170×60cm

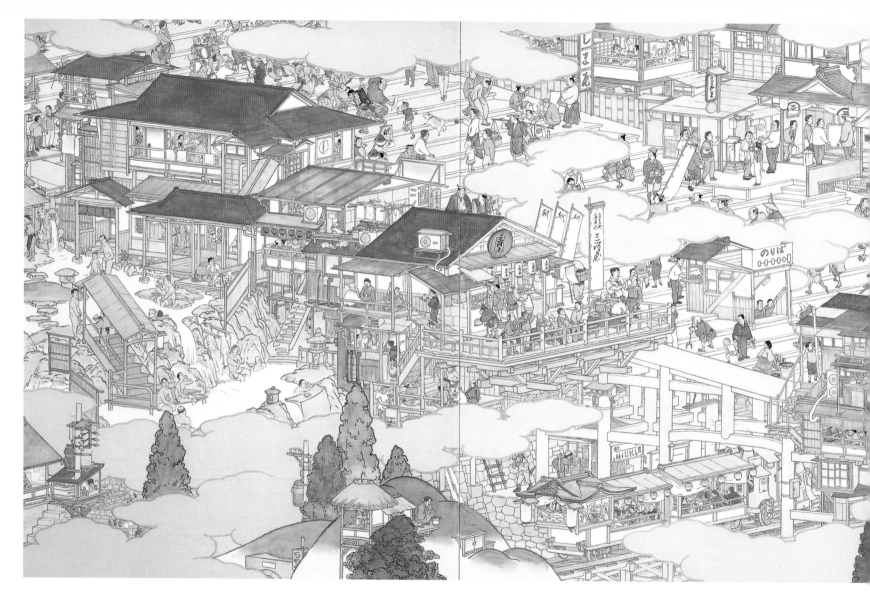

此の絵は静岡に在るがんセンターに掛ってゐます。
きれいで眺めの好い所のようです。

階段遊楽圖 2002 カンヴァスに油彩 91×290cm
Staircase of Amusements 2002 oil on canvas 91×290cm

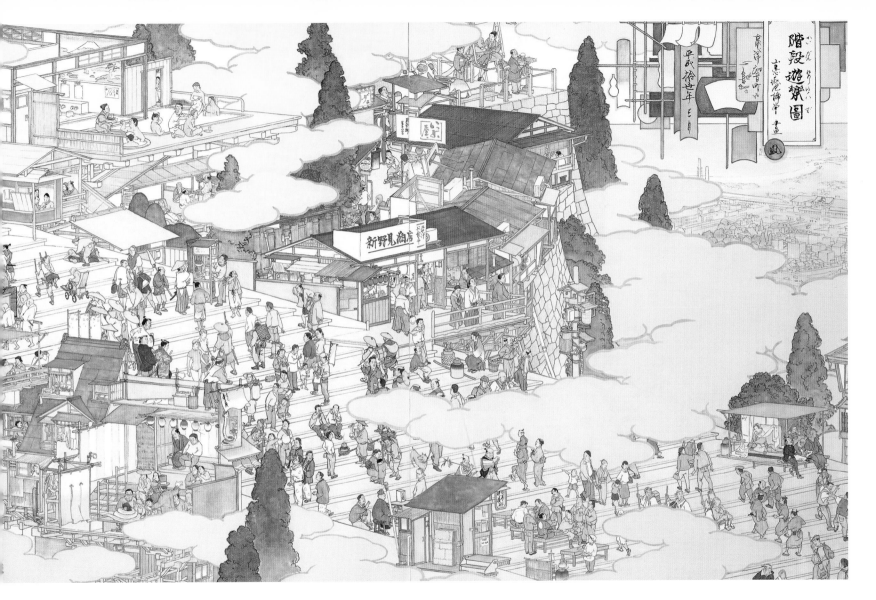

階段遊楽圖（部分）▶
Staircase of Amusements (Detail)

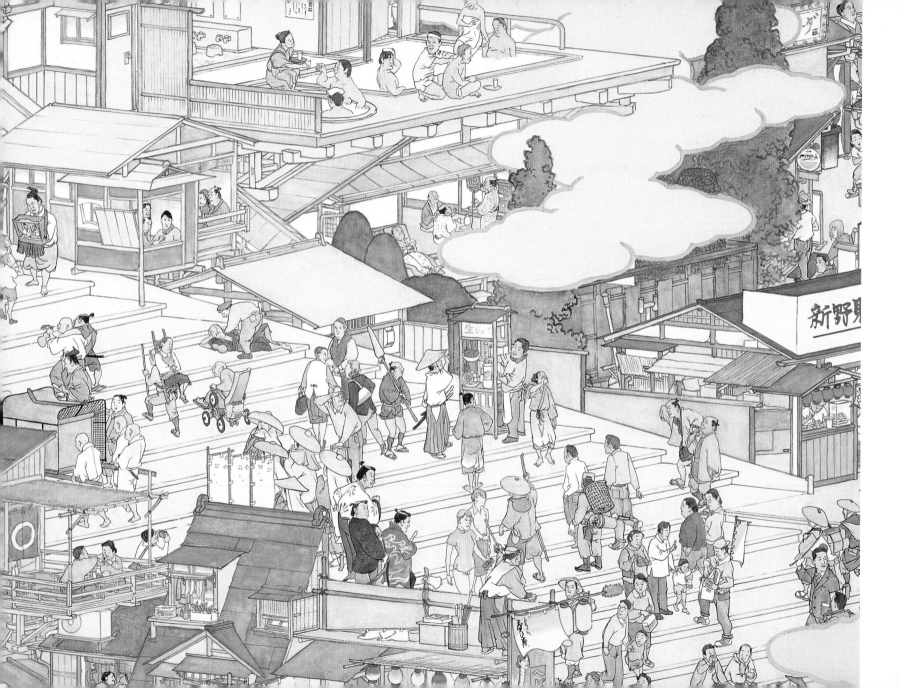

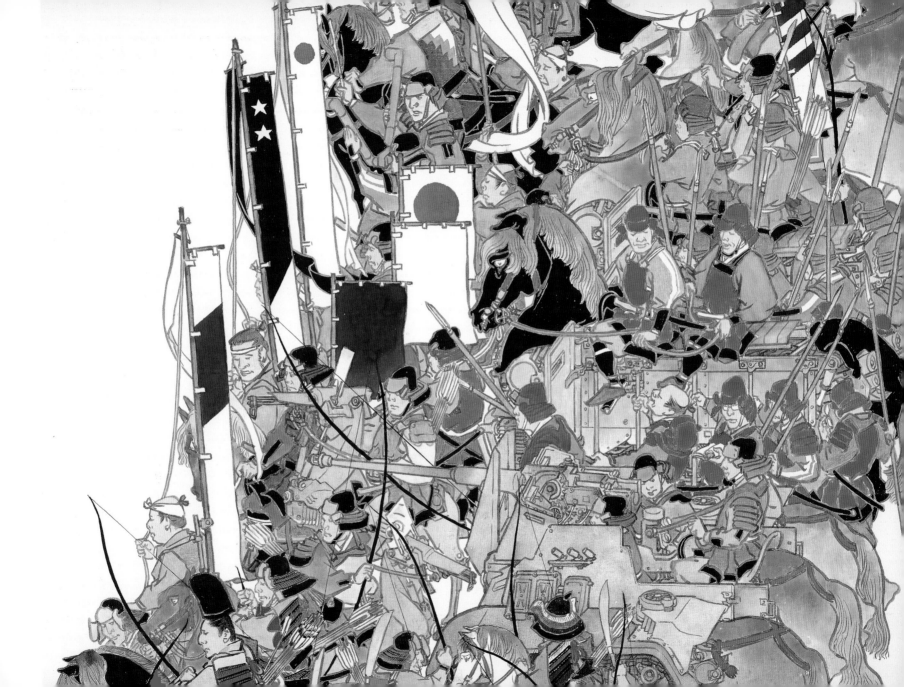

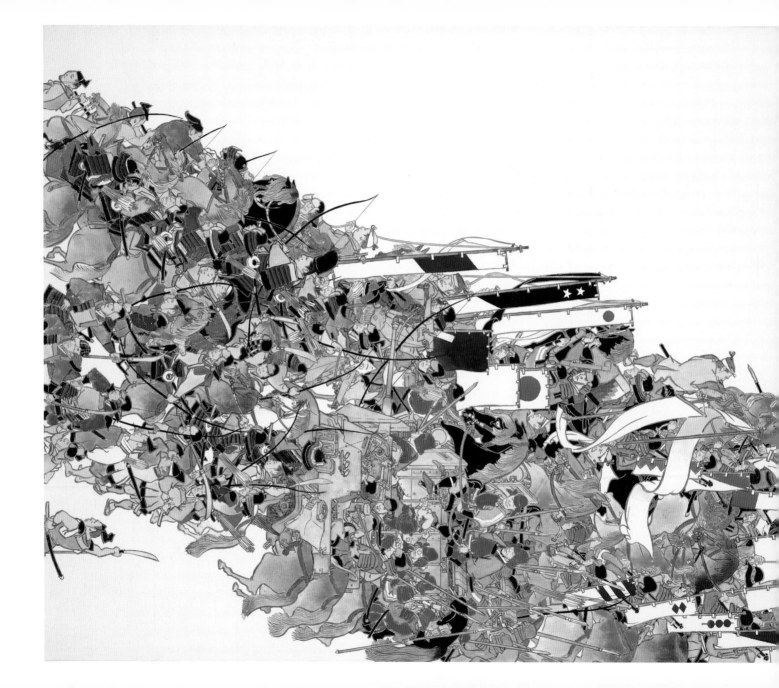

現代の作家がすべきものに、死んだ言葉を甦[よみが]らせる事があります。新しい抜け代[しろ]を作る事、それも自分の仕事の一ツと思っています。

當古おばか合戦─おばか軍本陣図 2001 カンヴァスに油彩、水彩 185×76cm
Postmodern Silly Battle: Headquarters of the Silly Forces 2001 oil, watercolor on canvas 185×76cm

▼ 當古おばか合戦─おばか軍本陣図（部分）
Postmodern Silly Battle: Headquarters of the Silly Forces (Detail)

21

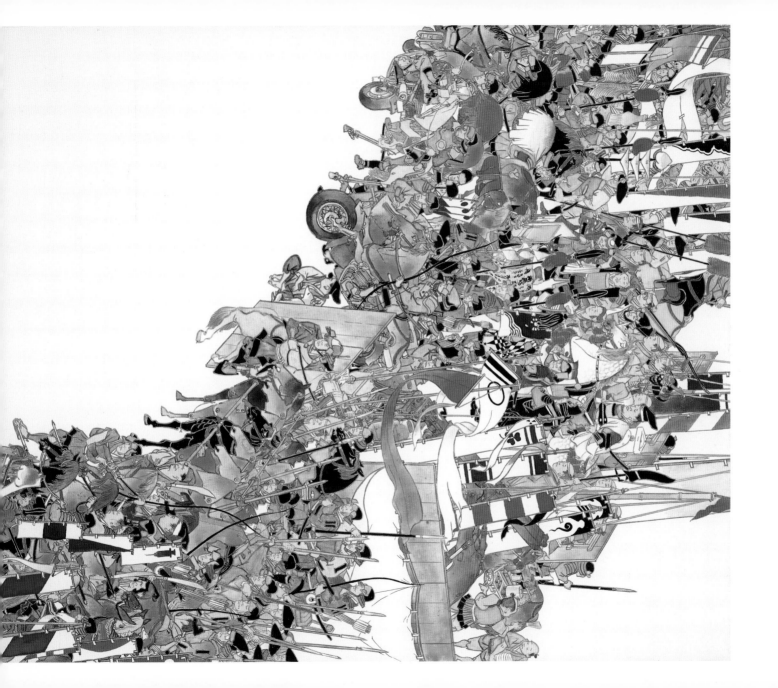

戦争反対と云うった展覧会に出品を頼まれて描きました。武器や鎧の恰好のよさを描くのが主眼です。

裏面には反復による偽厚感で、反戦運動を潰そうとする反戦家の漫画を描きました。

武具武人総覧圖 1996 紙に鉛筆、水彩 170×92cm
Weapons and Warriors 1996 pencil, watercolor on paper 170×92cm

19

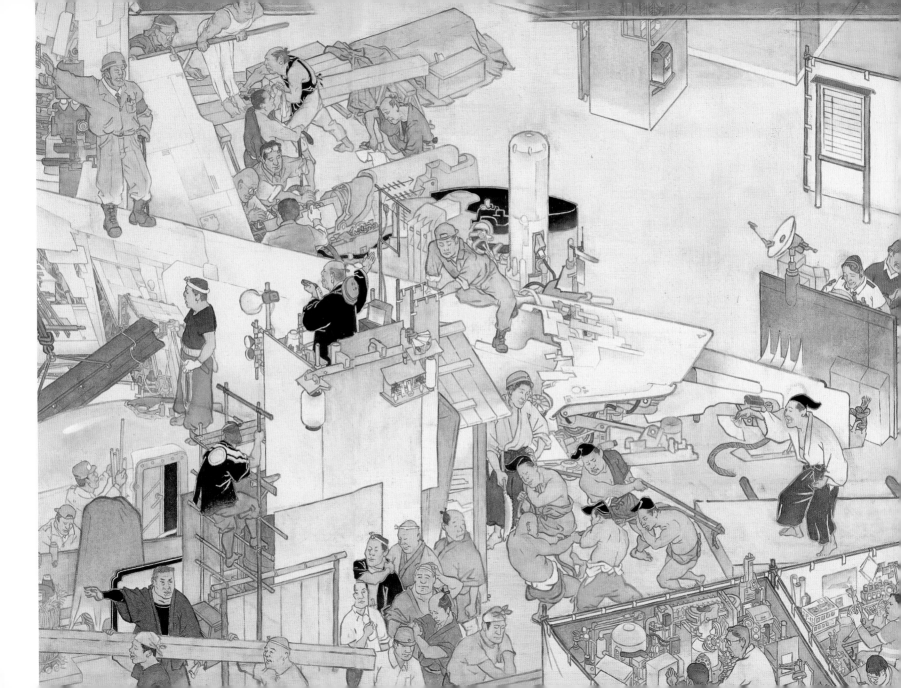

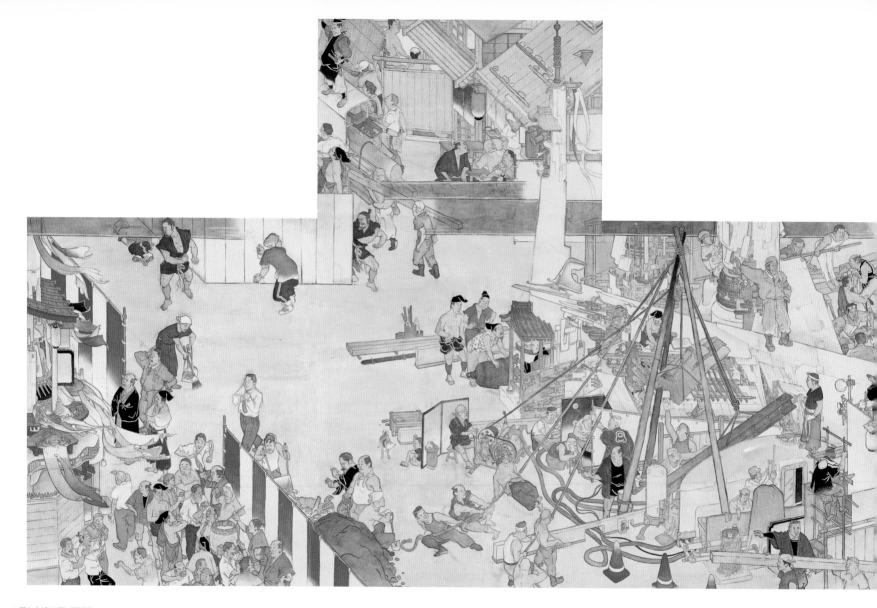

◀ 何かを造ル圖（部分）
People Making Things (Detail)

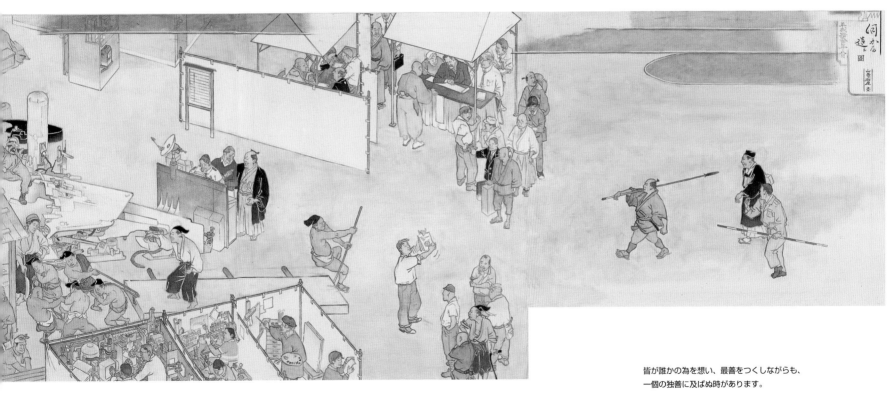

皆が誰かの為を想い、最善をつくしながらも、
一個の独善に及ばぬ時があります。

何かを造ル圖 2001 カンヴァスに油彩 112×372cm
People Making Things 2001 oil on canvas 112×372cm

16

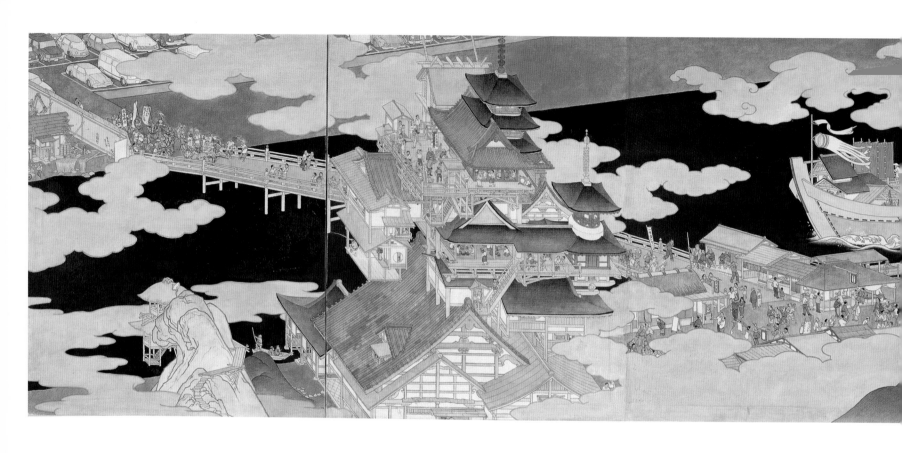

此の絵は「下図」と題された同寸の白描画と対になってゐます。
「下図」とありますが、本図より後に描かれたものです。此れも気取りの一ツでしょう。

今様遊楽圖 2000 カンヴァスに油彩 71×342cm
Modern Pleasures 2000 oil on canvas 71×342cm

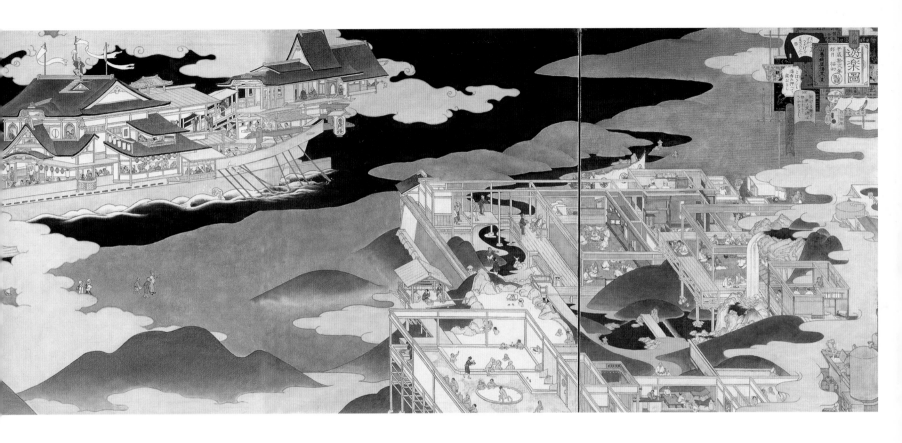

今様遊楽圖（部分）▶
Modern Pleasures (Detail)

14

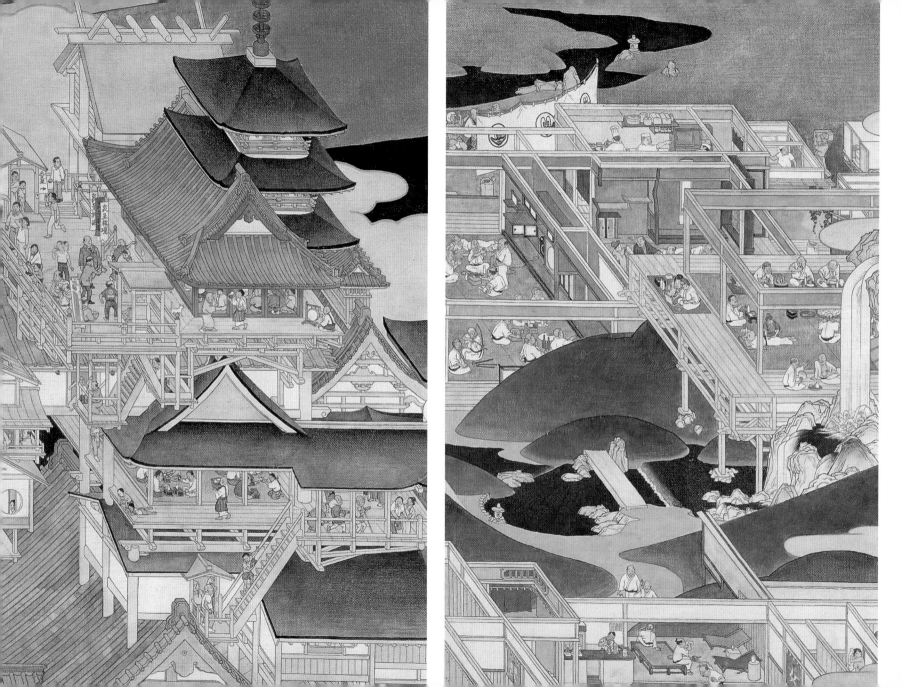

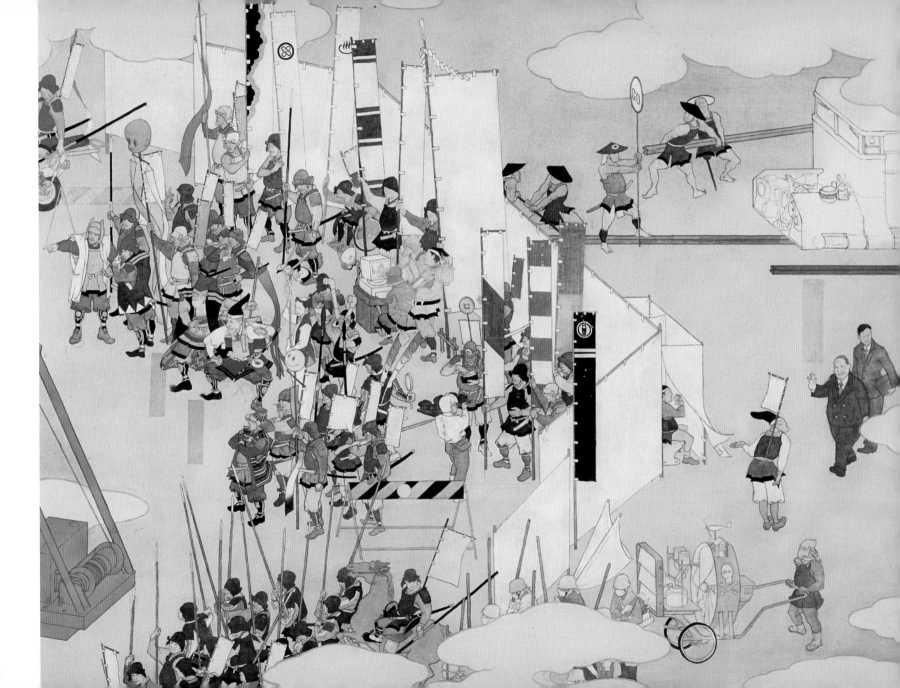

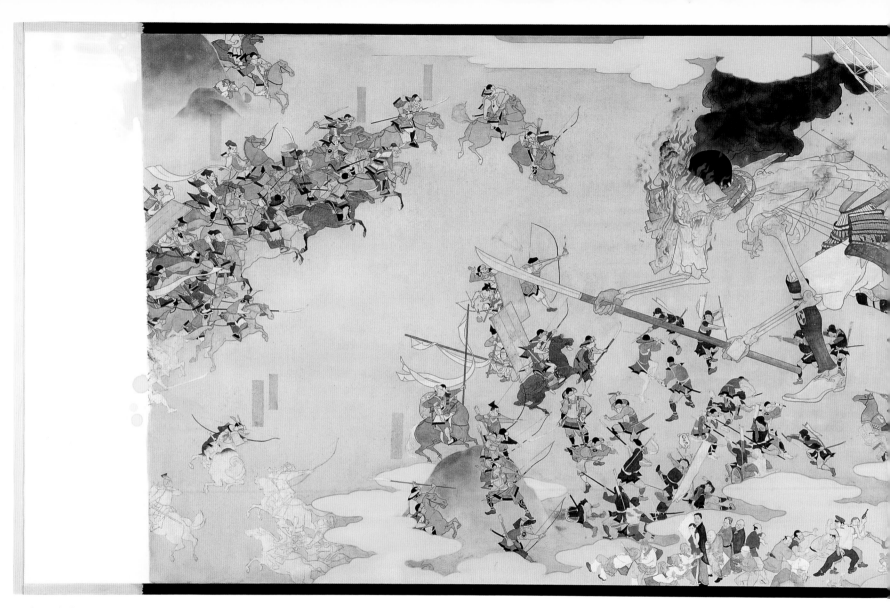

◀ 當苫おばか合戦（部分）
Postmodern Silly Battle (Detail)

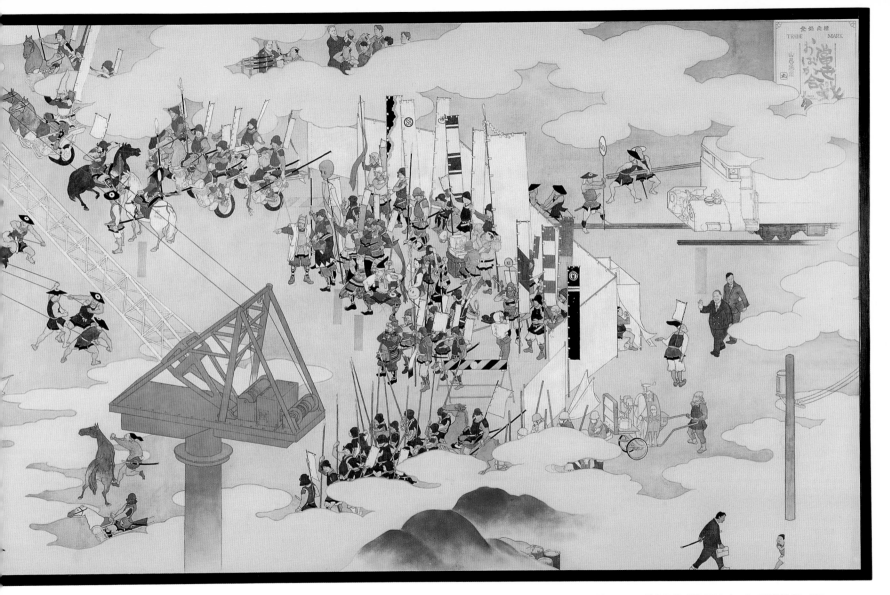

大画面の油絵を描く時は、どうも気取りが出ていけません。
端っこの塗り残しなどそれです。

當古おばか合戦 1999 カンヴァスに油彩 97×324cm
Postmodern Silly Battle 1999 oil on canvas 97×324cm

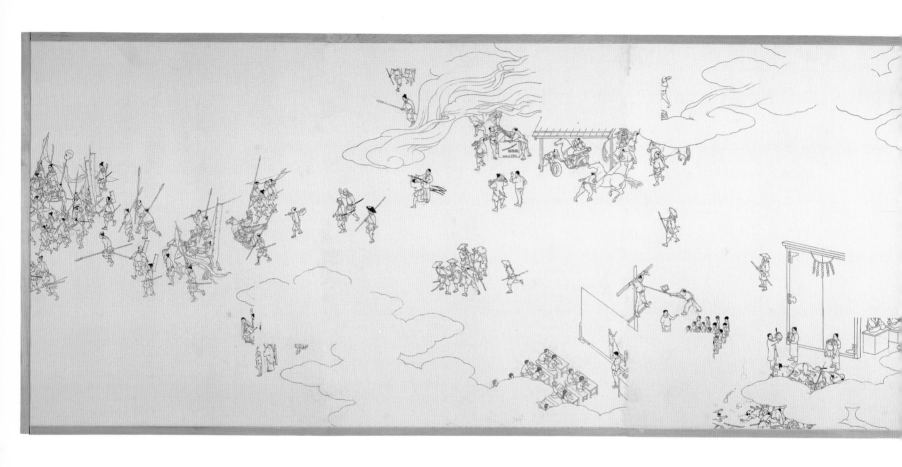

矛盾と云う言葉がありますが、口上の間は矛盾ではないのです。
時間が二つの真実を並立させてゐるからです。論理矛盾と云う事自体、矛盾してゐます。

當古おばか合戦　序の巻　1999　カンヴァスに鉛筆、油彩　81×390cm
Postmodern Silly Battle: Prologue　1999　pencil, oil on canvas　81×390cm

山愚痴諦抄—尻馬八艘飛乃段（部分）▶
Catalog of Complaints and Resignations: A Man Following Others Blindly (Detail)

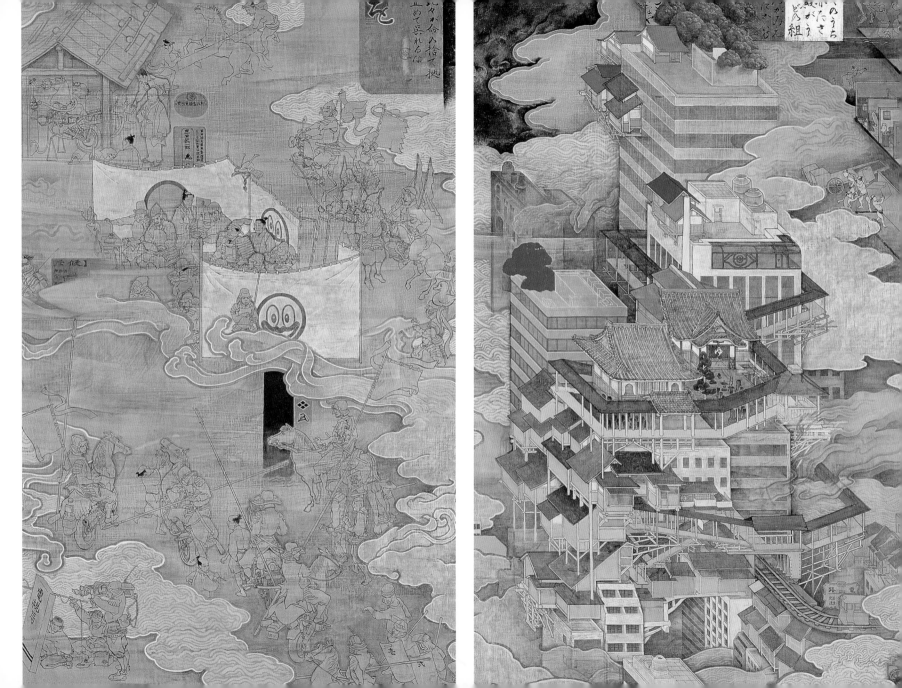

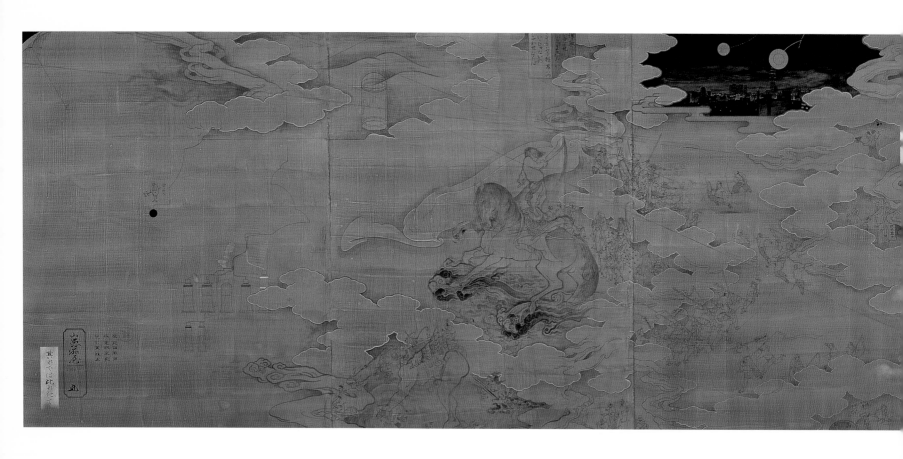

◀ 山乃愚痴明抄（部分）
Catalog of Complaints (Detail)

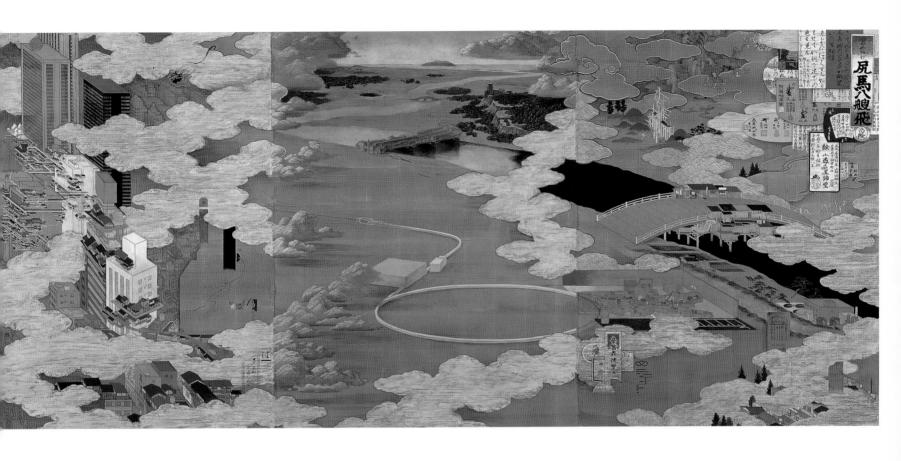

如何に古典をふまえるかを重要視した時代があり、亦たオリジナリテーとやらを重く見る時代もあり。
どちらにせよ、何にのせられているのか位は見極めたいものです。

山愚痴諦抄―尻馬八艘飛乃段　1998　カンヴァスに油彩　117.2×549cm
Catalog of Complaints and Resignations: A Man Following Others Blindly　1998　oil on canvas　117.2×549cm

4

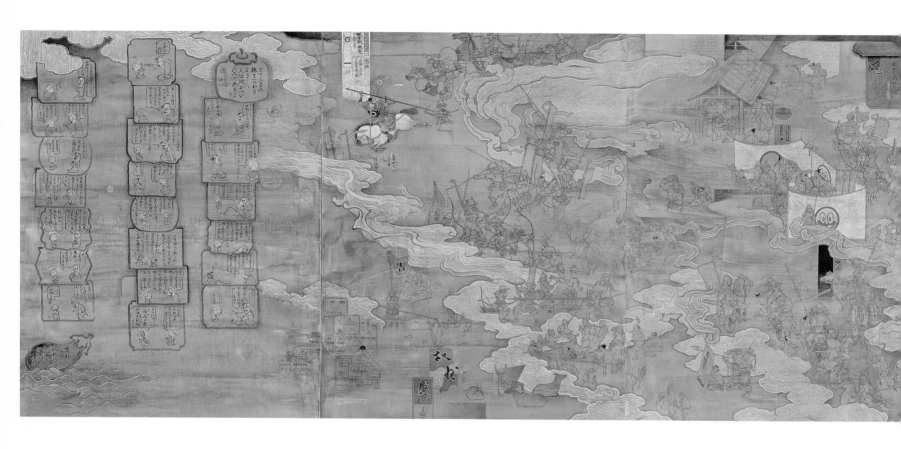

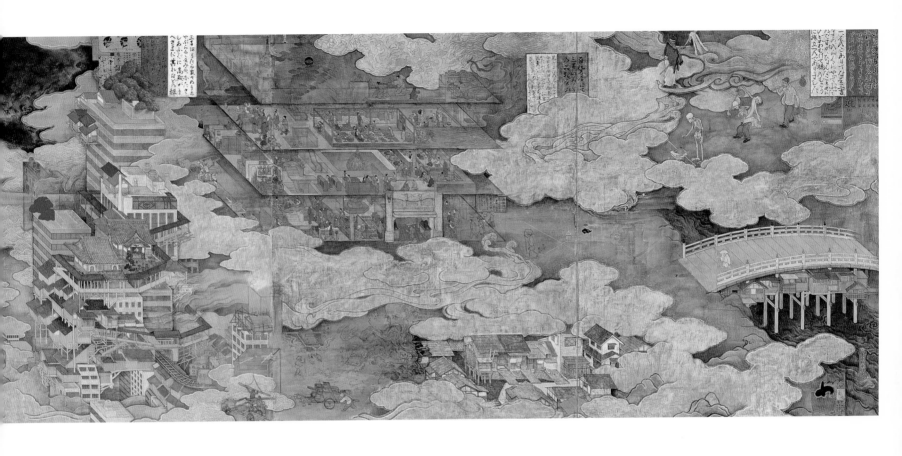

学生時代の作品を一つにまとめて修了制作としました。
しまいに解説漫画を描き加へて了としたのですが、言質をとられるばかりで困りました。

山乃愚痴明抄 1995 カンヴァスに油彩 91×436.2cm
Catalog of Complaints 1995 oil on canvas 91×436.2cm

群像・合戦圖

Samurai Warriors Ready for Battle

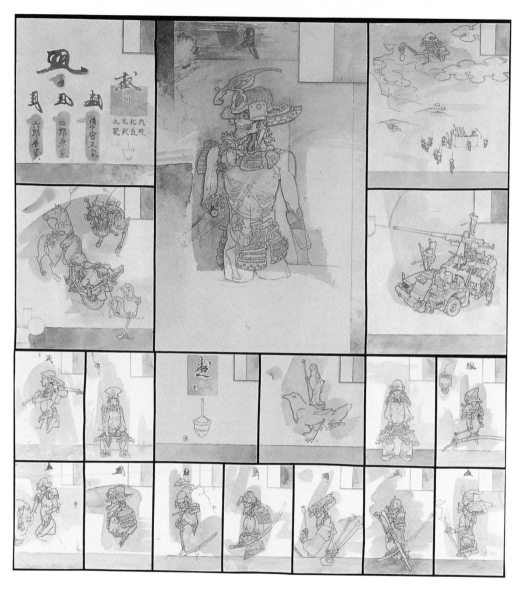

武具武人総覧圖（部分）
Weapons and Warriors (Detail)

表参道の書店ナディッフのギャラリーで開催される。会期中に、私は彼と対談する予定になっている。

「挿絵」とは、「ファインアート」や「現代美術」の対極にあるような言葉だが、彼は鏑木清方以来の、とびきりの挿絵画家としての資質を持っていると思う。褒めすぎか……。著作権の問題でお蔵入りしている、司馬遼太郎『坂の上の雲』の挿絵も、早く公にできることを祈っている。

さて、一九九八年の『上毛新聞』から六年後、桐生市出身の無名画家だった山口晃を取り巻く状況はすっかり変わって、二〇〇四年一月号の『美術手帖』は、「会田誠と山口晃」平成の画狂人たちのコンセプチュアルな冒険」という特集を組んだ。こと『美術手帖』的な「現代美術」の世界ではトップランナーのひとりとなった山口は、会田誠と対談して、最後にこう言っている。

（前略）北斎は日本の誇りのようにいわれるけど、あれはイギリスが狩野派を讃えるのをあてこすって、フランスが「北斎がすごい」と持ち上げたんですよ。まるっきりの記憶違いかもしれませんけど（笑）。北斎はどこから来たかと考えたことがあって、日本人はたぶん本当は歌川派とかのような、キッチュが好きなはずだと。むしろ外人が北斎のようなタイプを好む。日本美術史にも西洋の視点が影響している、といいますかね。それを再認識させられた自分というのと、自分が知らずに選びとっていた外国というのがあって、洋物百パーセントと思っていたものにじつは和物が混じっていたりする。逆もそう。（後略）

うーん、この、一見無口な「日本美術窃盗犯」は、かなり美術史家的な視点で、日本と西洋のねじれた関係を、こたつの中でねちねちと考えていたわけだ。

彼と会うと、大げさな美術史の話はなかなかできないんだけれど、今度、谷中で蕎麦でも食べながら、話してみようか、と思った。

この画集は、山口晃の仕事のほぼ全貌を伝える、初めての画集となる。だが、彼の絵は大きな画面や長い巻物が多いから、ここで、しびれるようなディテールを存分に示すのは難しい。ルーペのしおりはついているけれど……。どうぞ、個展等で、実物を見ていただきますよう、最後にお願いして、筆を措く。

二〇〇四年七月一四日

この新説の衝撃は大きく、シンポジウムが開かれ、新聞でも報道され（この本格的な第一報は、なんと九五年の地下鉄サリン事件当日の『読売新聞』夕刊に掲載された）、こと美術史研究の世界では、大問題になっていたのだった。

美術史学会の多くの人たちは、この新説を積極的に支持したいと思い、いくつかの文章を書いていた。そんな経緯は、拙著『日本美術の20世紀』（晶文社、二〇〇三年）にまとめておいたので、今度、山口君にもあげよう。

そんなことに深入りしている時期だったから、彼のこの作品が余計に心に染みて、欲しいと思った。確か、値段は六十万円ほどだったと思う。だが、私が見に行ったその日には、すでに赤いシールが貼ってあった。今でも、この絵を買い逃したことを、後悔している。

さて、それから五年後の二〇〇四年六月、私は滋賀県立近代美術館で、この「頼朝像図版写し」と久々に対面することとなった。開館二〇周年記念特別展『コピーの時代』。「デュシャンからウォーホル、モリムラへ」というサブタイトルがつけられている、気合いの入った展覧会である。

この会場に、私が欲しかった「頼朝像図版写し」が展示されていた。クレジットには、「高橋龍太郎氏蔵」。精神科医である高橋先生は、それにしても、私が欲しかった絵を、ことごとく先に買っている。会田誠の「紐育空爆之図」しかり、「美しい旗」しかり……。コレクターとしては、完全に負けている。悔しい。

『コピーの時代』展には、山口の新作「厩圖2004」（45頁）も出品されていた。カタログには、もとになった東京国立博物館の「厩圖」の写真も、参考図版として載っている。この室町から江戸初期にかけて流行した厩図という画題。数十点の現存作品があるが、おそらく山口が実見したのは、この東京国立博物館本など、ごくわずかだろう。しかし彼は、図版を通じて、こうした近世初期風俗画を源泉としてイメージを培養して、次々と連作を産んでいる。一連の洛中洛外図などの近世初期風俗画を源泉とする作品についても同様だ。

他にも、北斎をはじめとする浮世絵、江戸初期の相応寺屏風などの邸内遊楽図、寺院に奉納された絵馬、地獄絵、合戦図など、彼のイメージの源泉は、日本の古美術全般にわたって、かなり幅広い。そして、そのイメージの取捨選択は、徹底した「趣味」に貫かれている。「テーゼ」ではなく、「趣味」。これを馬鹿にしてはいけない。現代美術作家諸君よ、と私は言いたい。

山口晃は、自らの「趣味」で日本美術史を取捨選択し、軽々と窃盗犯となり、その獲物のエッセンスをこたつの中で培養する。その趣味には、ブリューゲルも、松本零二の「宇宙戦艦大和」も、司馬遼太郎も、澁澤龍彦も、複雑に組み込まれ、彼の頭の中で濾過されて、私を『魅了する』作品をシコシコ描いているのである。

ここ数年、山口晃の絵に対する注目度は、加速度的に上昇していった。毎年開かれて、あっという間に完売する、ミズマアートギャラリーの個展を軸として、二〇〇〇年の『現代美術百貨展』（山梨県立美術館）、二〇〇二年の『新版 日本の美術』（同）、二〇〇四年の『私はどこから来たのか／そしてどこへ行くのか』（東京都現代美術館）、そしてかの『コピーの時代』など、本格的なグループ展への出品が相次いでいる。

展覧会とは別に、六本木ヒルズの鳥瞰図（54頁、55頁）を描いて、ミュージアム・グッズとなったり、今秋には日本橋三越の百周年事業に向けて、やはり鳥瞰図を描いているという。さらに、私もエッセイを寄せた平凡社の『澁澤龍彦 ホラー・ドラコニア 少女小説集成』全五巻（二〇〇三〜〇四年）のうち、二巻の挿絵を担当し、その出来映えには、私も舌を巻いた。草葉の陰の澁澤も、きっと喜んでくれたに違いない。その原画展は、この夏、

レーションによる『こたつ派』展（ミヅマアートギャラリー）に出品し、出品作家四人のうちの一人として、ごく一部で注目された山口だが、個展は初めて。残念ながら、私はこの初めての個展を見ていない。

私が初めて彼の絵の実物に接したのは、翌九九年。やはりミヅマアートギャラリーの、「借景」と題された個展。この折にも、『上毛新聞』は、一年前とほとんど同じ体裁で、「大和絵の形式で現代を描写」という見出しをつけて、小さな記事を掲載している。

桐生市出身の画家、山口晃さん＝東京都台東区＝が、日本伝統の大和絵の形式を借りて現代を描写したユニークな個展「借景」が、東京都渋谷区神宮前のミヅマアートギャラリーで開かれており、訪れた人たちを魅了している。

一年前と違うのは、桐生市の「元宿町」と、芸大の助手という肩書きがとれて、「訪れた人たちを魅了している」というレポートがついていること。この一年の口ぶりの微妙な変化が面白い。ありがちな常套句と言えなくもないが、この個展を見た私は、確かに「魅了」されたのだった。記事は正しい。

もう五年前になるが、この個展のことを、思い出してみる。

表参道から歩いて五分ほどのところにあった、ミヅマアートギャラリー（その後、中目黒に移転した）。入り口のガラスのドアを開けて左奥の壁面に、「頼朝像図版写し」という二枚組の作品（61頁）が展示してあった。壁面に掛けられた二枚の絵の前には、それぞれ棚が設えてあって、かの「源頼朝像」を掲載した画集が拡げてあった。他にもいくつかの大きな作品が展示されていたが、この個展の会場で、初めて山口晃と会って、話をしたのは、この絵だった。記憶が曖昧だが、彼のこの作品の発想のもとになった「源頼朝像」のことを集中的に調べていたころの私は、その「源頼朝像」に注視したのは、この絵だった。そのころの私は、彼のこの作品の発想のもとになった「源頼朝像」のことを集中的に調べていて、確か、「この絵、源頼朝の肖像じゃないって知ってる？」などと、美術史家ヅラして、偉そうに話したのだった。

ここでちょっと説明が必要だろう。山口は、昭和四〇年代に出版された小学館『原色日本の美術』の古い図版と、近年の展覧会カタログに掲載された図版を、そのあまりにも印象が異なる図版を、油絵具でそっくり写して、作品とした。あらためて図版を見ると、この間に修復されたことによって、新しい図版では黒い衣の地模様がずいぶん判別できるようになっているし、写真の露出がアンダーか、オーバーかによって、かなり違った印象を受ける。「こたつ派」である彼は、この図版を穴が開くほど眺めながら、その印象のギャップを忠実に再現した。

私とて、若い時には、どてらを着て、こたつで図版を注視しながら、シコシコと誰も読まないような「学術論文」を書いてきたから、図版と現物との落差に、「何なんだよ！」という思いを何度もしてきた。だから、この作品に込めた彼の思いは、薄っぺらいシミュレーショニズムとは一線を画す、誠実な営みによるものだと思った。

ところで、私は彼に言った「この絵、源頼朝じゃないって知ってる？」という言葉が、近年の日本美術史研究における大問題を反映していることを、まだそれほど多くの方が理解されているわけではないだろう。

一九九五年に発表された米倉迪夫氏の『源頼朝像　沈黙の肖像画』（平凡社）は、かの、教科書にも必ず載る源頼朝像の像主が、実は頼朝ではなく足利直義であり、制作年代も一二世紀ではなく一四世紀である、という、これまでの定説がひっくり返るような新説を提示したのだった。

vi

日本美術窃盗犯

被疑者・山口晃の場合

山下裕二

一九九八年六月一一日付の『上毛新聞』に、山口晃の個展を紹介する、小さな記事が載っている。見出しは、「遊び心あふれる20点 20日まで、東京で、個展 桐生出身の山口さん」（傍点筆者）。

「東京で」という口ぶりに、なんとも言えない、地方紙の文化欄ならではの哀愁が漂う。「山口さん」といわれても、桐生の親類縁者以外は、ほとんど誰のことだかわからなかっただろうが、この記事を見て、「あ、あの絵が上手かった山口君だ……」と思い出した、同級生や近所の人も、五人ぐらいはいたかもしれない。

絵の前で、どうポーズしていいか困ったような顔をする彼の写真には、「会場で自作について語る山口さん」というキャプションが添えられて、時代の障壁画にひかれる。技法や筆法は突き詰めればきりがないが、それで絵が堅くなるのも嫌ですし、やらずに絵が弱くなるのも困る。安っぽさも含めて、これからも『遊び』を残しておきたい」というコメントが載る。

ほとんど無名だったころのこの記事を読んで、いま、私はあらためてはっとした。そうか、彼の絵の源泉には、ブリューゲルがあったのか、と。

ここ数年、急速に注目されるようになった彼は、「現代の大和絵師」などと、おそらく本人も辟易しているであろう、「ユルい」フレーズで括られるのが常だが、百年後の美術史家は、そんな常套句に惑わされてはいけない。

私とて、この文章を、「日本美術史の権威」として引っぱり出されて、「大和絵の形式を引用し現代日本をユーモラスに活写する作風で知られる……」などと持ち上げて書く気は、さらさらない。そんな状況は、山口晃自身が、すでにコケにしていて、二〇〇三年の個展の「山愚痴屋澱エンナーレ 2003」では、この常套句を逆手に取った、なんとも皮肉っぽいインスタレーションを手がけているのだった。

さて、この『上毛新聞』の記事を書いた記者がどんな人なのか知らないが、大新聞の記者のように、下手な価値判断を交えず、作家のナマの声をある意味愚直に伝えてくれるから、この誰も目に留めないような記事は、貴重な「美術史的文献」となっているのだ。記事の本文は、こんなふうに始まる。

桐生市元宿町出身で、東京芸大油絵科助手の山口晃さん（二八）＝東京都台東区＝の初めての東京個展が東京・表参道のミヅマアートギャラリーで、二十日まで開かれている。山口さんは、大学院時代に故郷の桐生市で作品展示を行ったことがあるが、本格的な個展は今回が初めて。

この個展が、実質的なデビューだったわけだ。この前年、九七年六月には、会田誠キュ

端　書　き

山口　晃

学生の頃、著名な建築家の講演が学内で催され、参加した。質疑応答となり音楽学部の学生が発言したが、「ジョン・ケージ以後、私たちの……」と云う始まりに仰天した。仰天はオーバーにしても、強い違和感を覚へたのは確かであり、何となれば外国の音楽家の数分間音を出さぬと云う作曲を、己の基底に据えると云う肥大ぶりに呆れたのだ。質問の全体像や応答の内容は忘れたが、そこではたと考へこんだものである。我が身を振り返るに、美術史の中に己が作品を置いた事は無かったのか、古への作家と我が胸で語りおうた事は無かったのか。美術史なり美術に言及する事が、真摯さを装った自己肥大の手段となりうる事を大きに危ぶんだ記憶がある。

其んな事を最近、つら〳〵と思い返しながら、はて何を其んなに危ぶんでおったのかといぶかしんだ。どうも徒に己を矮小化して清らぶっていたのではないか、文化のダイナミズムを固定化して据えておったのではないか。

あるはずみで何かを錯覚した者が良い仕事をせぬとも限らない。乗った尻馬の、ついには首根っこを押さへて引き回されぬとも限らない。「ぬけ〳〵と」と云う恩師の言葉が此の頃、思い出されてならない。時に私を後じさらせ、時に其の反動を与ふ。

誰が見るやも知れぬ図録の端書きを、のう〳〵と致しおるのも反動やもしれず、明日にはあとじさってゐるかも知れない。

ひとまずは御高覧下され度く、お願い申し上る次第。さてもいた、まれぬ事。

山口晃作品集【目次】

The Art of Akira Yamaguchi / Akira Yamaguchi / University of Tokyo Press, 2004 / ISBN 4-13-083100-3

山口晃作品集

The Art of Akira Yamaguchi

東京大学出版会

University of Tokyo Press